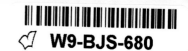

Praise for *How Design Makes the World*

"Nobody's better at explaining how the world really works than Scott Berkun."

JEFFREY ZELDMAN, web design legend and cofounder of *A List Apart*

"What makes a Jacuzzi better than a Segway? Why do street grids work in some cities, but maybe not in yours? What's wrong with calling an interface 'intuitive'? This fascinating book will help you see design everywhere and question why it works —or why it fails."

ELLEN LUPTON, curator of contemporary design at Cooper Hewitt, Smithsonian Design Museum

"An invaluable, essential resource that demystifies and democratizes design for everyone who lives with it—which is to say, all of us."

KHOI VINH, principal designer at Adobe and former design director of the *New York Times*

"Scott Berkun captures the essence of what makes design so incredibly important in our lives. He frames how we should think about design in a fun and accessible way. *How Design Makes the World* explains why our world is the way it is, and lays out the questions we need to ask to make it better."

JARED SPOOL, founder of User Interface Engineering

"Everyone in the tech world knows that they need design, but few understand what it is and how it will help them succeed. Scott Berkun illuminates both the problem and the solution. A brilliant book."

ALAN COOPER, design pioneer and author of *About Face*

"Anyone can understand the designed world with this insightful and compelling primer. The daring will use their new understanding to analyze and improve their own worlds."

ASHLEIGH AXIOS, chief experience officer at &Partners and president-elect of the American Institute of Graphic Arts

"Design does indeed make the world, and Scott Berkun has written a highly readable book about this fact."

HENRY PETROSKI, author of *Small Things Considered: Why There Is No Perfect Design*

"Design impacts everyone, but does everyone understand good design? If they read this book, they will."

SAM AQUILLANO, executive director of the Design Museum Foundation

"Scott Berkun shows the true impact of design on the world and makes it fun to discover a new way to think and see."

MATTHEW LEACOCK, creator of the Pandemic board game

"Whether you're figuring out what 'design' even means or you're a designer looking to better explain what you do, you'll be enlightened and entertained."

KAREN MCGRANE, principal of Bond Art + Science and faculty member at the School of Visual Arts

"After reading *How Design Makes the World*, you'll know who to thank when you make the perfect toast, who to blame when you miss your flight and who to ridicule when you see that Segway tour drive on by."

"Design is an inescapable force in our lives that determines our fates, whether or not we are aware of it. Scott Berkun makes a compelling case for how design makes our world, while helping us ensure it will make our lives better."

"Don't be fooled by the size of this powerful little book. It's packed with clever writing, insightful histories and compelling questions, showing us that design is all around us, and designers are needed now more than ever."

"If you want to discover your ability to shape the world, or learn how others secretly shape it for you, this book is a fun, quick primer."

"*How Design Makes the World* is insightful, funny and thought-provoking. You won't look at the world around you the same way—and that is a good thing."

"Design not only makes the world we live in—it is all things worldly. Scott Berkun's clear, concise and inspiring book makes a brilliant case for the ubiquity of design in all aspects of life."

STEVEN HELLER, cochair of the Design MFA program at the School of Visual Arts and AIGA medal winner

"This thoroughly enjoyable book weaves together stories and insights about the important things around us—those we see and those we don't—explaining in everyday language how they came to be. The perfect book for anyone who wants to take a fresh look at the world."

ANNA SLAFER, vice president of exhibitions and programs at the International Spy Museum

"An amazingly concise overview of the fundamentals of design. Scott Berkun helps you look at everything in this world in a new way. An awesome book."

JOHN VECHEY, cocreator of Bejeweled and cofounder of PopCap Games

"To write a concise, engaging yet insightful book about something as unwieldy, yet fundamentally important as design is quite an art, and Scott Berkun has done it. He makes clear design's impact using real-world examples of toasters and cities, door handles and health care systems, social media and seat belts."

DAN HILL, author of *Dark Matter and Trojan Horses: A Strategic Design Vocabulary*

"Scott Berkun helps us see the pervasive influence design has on every part of our lives and its profound influence on all we do. You won't see the world the same way after reading this book."

AARRON WALTER, VP of design education at InVision

"Reading *How Design Makes the World* inspires you to see everyday things in a new way, helping you to ask the right questions. How does it work and for whom? Will it work for years to come? And most of all, you'll see how beautifully designed things come from beautiful teams."

LILI CHENG, vice president of conversational AI at Microsoft

"Design impacts every moment of our lives. This book will help you see design and even participate in it."

ROBIN WILLIAMS, author of *The Non-Designer's Design Book*

HOW DESIGN
MAKES
THE WORLD

SCOTT BERKUN

HOW DESIGN MAKES THE WORLD

Berkun Media

ISBN 978-0-9838731-8-1 (paperback)
ISBN 978-0-9838731-7-4 (ebook)

Published by Berkun Media LLC
scottberkun.com

Produced by Page Two
www.pagetwo.com

designmtw.com

CONTENTS

INTRODUCTION

WHAT IS YOUR favorite thing in the world? Why is it better than everything else? The answer is how it was designed.

There are hidden reasons why the world works the way it does. This book will explain many of them to you through the lens of good design. No prior knowledge is required, only curiosity.

I've worked for years to make this a fun, fast, challenging and memorable read, and I hope that's what you experience inside. I've always been fascinated by how everything in the world works, and how it doesn't, and I hope I can spark a similar passion in you.

When you finish, please join me online, where the conversation can continue. You'll find more stories and bonus resources there. I'll see you at designmtw.com.

1

EVERYTHING HAS
A DESIGN

EVERYTHING IN YOUR life was designed by someone. Look at
the chair you sit in, the software you use or the organization
you work for: they were all made by other people. The bound-
aries of nations on maps and the names of the towns you've
lived in were all chosen by people, too. Except for the natural
world, if you look at everything you have ever loved, hated,
used or purchased (and even the money you used to pay for
it), it was all designed and made by human beings. Design-
ers made hundreds of decisions over weeks, months or years
to create these things in your life. They had many possible
choices, but you only get to experience their final decisions,
for better or for worse.

This is more than just an observation: it's a powerful way
to understand the world, and everything that happens. Con-
sider the Notre-Dame cathedral in Paris, France. It took more
than a century to make. Construction started in 1163 and
wasn't complete until 1345 (so if you struggle to plan for next
month, don't get into the cathedral business). Over the last six
hundred years it has become one of the most popular works

of architecture, receiving thirteen million visitors annually, nearly twice as many as the Eiffel Tower.

On April 15, 2019, a fire started below the cathedral's massive attic, spreading quickly through the aging wooden beams and rising up into the roof. Within an hour, the iconic rooftop spire, weighing 750 tons, collapsed, creating a blast of energy so powerful that it shut all of the doors inside the building. The fire was so intense that it wasn't clear in the early stages whether the cathedral could be saved, but with heroic efforts by firefighters, it survived.

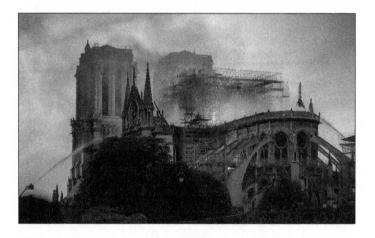

The cause of the fire is still unknown. However, we do know something about the design of its fire alarm system. As the *New York Times* explained:

> The fire warning system at Notre-Dame took dozens of experts six years to put together, and in the end involved thousands of pages of diagrams, maps, spreadsheets and contracts...[1]

This complexity would be the cathedral's undoing. At 6:18 p.m. on the night of April 15, an inexperienced security employee, working an extra shift to cover for a coworker, saw a warning on the fire safety system. It first told him what quadrant of the building might have a fire in it, "Attic Nave Sacristy," and then a code:

ZDA-110-3-15-1

It's unclear how much of this message the guard understood. The code referred to a specific detection device, but there was no way the guard could have known how to use this code to locate the fire. The system wasn't designed to make this easy to understand. And his job wasn't designed with the training to close that knowledge gap. He did call the guard inside the church and asked him to investigate. The problem was that there were two attics in the cathedral, and the church guard went to the wrong one.

It took twenty-five minutes, as the fire spread quietly hundreds of feet above their heads, for them to realize their mistake. By the time the church guard climbed the three hundred steps to the main attic, the fire was raging out of control. They finally called the fire department, but the damage had already been done. The fire had been growing for at least thirty minutes in total, tearing through the attic's wooden beams and support structures.

What good is a fire alarm system that's hard to understand? Not good at all. We like to think that, here in the present day, with almost nine hundred years of technological progress from the time the Notre-Dame cathedral was designed, failures like this would be impossible. The truth is that designing things well isn't easy to do. And as a result, things that are

hard to understand or that don't work well are made all the time. Often we just overlook them.

One classic example of bad design, often used as a cautionary lesson in professional design training, is what's called a Norman door, named after usability expert Don Norman. It's used so often in classes that many designers find it a cliché to mention it (if this is you, a twist is coming). In short, a Norman door is one that's designed without regard for how people naturally interact with things in the world. Here's an example:

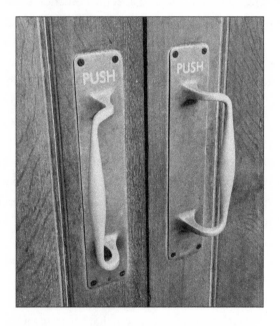

The problem with this door is the handle. Its shape tells your brain that you should grab and pull, like a handle on a briefcase or a car door. However, the door in this photo has a single instruction: PUSH. Which one is it then: push or pull? If we were looking at a Boeing 787 airplane cockpit

or the controls for a Virginia-class nuclear submarine we would naturally feel overwhelmed, but a door is among the simplest machines in the history of civilization. We should have greater than 50/50 odds for opening it safely. A well-designed object is one we don't have to think about. It makes the right choice the easiest one. But when we pull or push on a door and it doesn't open we're rightfully annoyed.

Once you start looking, you'll find confusing doors everywhere. Many modern offices have glass doors with metal handles, but the handles rarely suggest which way the doors open. A better design, one that's foolproof because it matches how people's brains work, is this, where the shape of the panel itself, even without text, suggests what your hand should do:

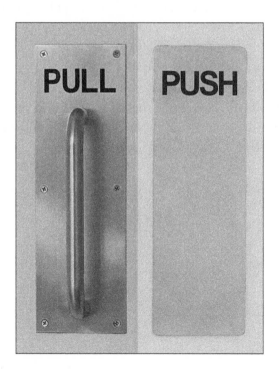

But why then are Norman doors so common? Or, more importantly, why do so many things in our daily lives have flaws built into them? There's likely something that annoys you about your apartment or home, perhaps a window designed not to open, a room that's always too hot or cold or a noisy pipe that wakes you in the night. Maybe you use confusing software that often crashes, or take a two-hour commute in stressful traffic each day. It could be a plastic clamshell product package that's impossible to open or a confusing government form you have to fill out. Perhaps, in more worldly moments, you wonder why war, crime and our climate-change crisis are part of the "civilized" world, despite how few people desire them. These things didn't magically appear in our society one day. It's the totality of all the choices people have made, perhaps accumulated over years or generations, that explains everything we experience, and defines who benefits and who does not.

Of course, no one intends to make bad things, despite how many of them there are. Which raises the question: why are so many things in the world, like Notre-Dame's fire alarm system or Norman doors, not designed very well?

2

BUILDING VS. DESIGNING

TO UNDERSTAND THE world, we first need to acknowledge the state of the universe: it is designed to kill us. More precisely, as best as we can tell, it doesn't care, or even know about us. We're lucky just to be here. In all of the indifference of infinite space, there is just one pale blue dot, where, for the moment, we have inherited a habitat in which we can survive. This improbability, combined with our uncommon talents to make tools, grow food and transfer knowledge to future generations, all without killing each other (too much), explains why we've lasted this long. But this took effort to achieve. Except for nature's gifts, we have rarely obtained good design for free.

In people terms, it's useful to think of good design as a kind of quality, and higher quality requires more skill, money or time. This means that anyone who makes something is under pressure to decide how much of their limited resources to spend on which kinds of quality. Should it be more affordable? Should it be easier to use? Should it be more attractive? It's hard to achieve them all. Running a business isn't easy,

and most people, most of the time, are looking for less work to do, not more.

To explore these ideas, imagine, as a simplified example, there is a company called SuperAmazingDoorCo. They pride themselves on their idea of quality: making sturdy, reliable doors. Let's pretend they manufacture the door shown earlier, the confusing one, but they don't know it's confusing because sales have been good and they've heard few complaints. Their CEO is a proud businessperson who wants the company to be even more successful. To her, the company and its doors are designed well, since it's making a profit and customers seem happy.

The CEO hires you to be the project leader for a new version of their bestselling door. A team of experts at the company from across engineering, marketing and sales is brought in to work with you. In the first project meeting, some important questions come up:

- **From engineering:** Will the new door fit in standard office building doorframes?
- **From sales:** Will it look good in the online catalog?
- **From marketing:** Can it have optional locks? Customers want them.
- **From the boss:** Can we get this done before next year?

These questions seem fine, if shallow, at first, but something is missing. None of these questions will help the team learn about how confusing these doors are to use. This project will still build a door, but the odds are low that it will be an easy-to-use door, since no one has clearly defined what "a good door" means for the people who use it. Regarding ease

of use, and most kinds of quality, often **building things is easier than designing things.** This doesn't mean building is easy. Building can be challenging work. Planning and installing the complex fire alarm system at Notre-Dame was very hard. But to *build*, as I'm using the word, means the goal is to finish building. To *design*, or to design well, means the goal is to improve something for someone. This means that just because you built the thing the right way doesn't mean you built the right thing. That's the missing question from the list: How well does the current door work for the people who use it? And how can we make it better? That is, assuming we decide to care about this kind of quality. As the world demonstrates, not everyone does.

This is where designers come in. Or, at least, where they should. Designers are experts at designing good things, and they use well-established methods to do it. Good designers, especially ones who care about the experience people have with what they create, depend on observational psychology and usability studies, actually watching real people as they try to use things to learn what confuses people. They also use knowledge derived from anthropology, fine art, psychology and engineering, and our ten-thousand-plus-year history of making things for people, from axes to arrowheads to mobile apps. That missing question from the project meeting is actually the first one that most designers, and design researchers, ask.

But many organizations don't hire designers, so the questions that need to be asked never come up. And, as a result, the folks at SuperAmazingDoorCo proudly believe they make great doors, even though they don't (at least as far as the people who try to open them are concerned). This is what

psychologist Noel Burch called unconscious incompetence, where a person is unaware that they are bad at something (which may remind you of certain friends or coworkers).[1] The way they work, not observing customers or hiring good designers, keeps them blind from the truth and unaware of their incompetence. Much of the bad design in the world is the result of incompetence, unconscious or otherwise. As book designer Douglas Martin explains, "The question about whether design is necessary or affordable is beside the point. Design is inevitable. The alternative to good design is bad design, not no design at all."[2]

Yet sometimes bad experiences happen because you're using something that was designed to solve someone else's problem. It's like trying on a shirt two sizes too large or too small: the design itself might be OK for another person, but it's a mismatch for you. Maybe all of the ones that fit you have already been taken, or it could be the designer's failure to consider the sizes and genders of who they were designing for (unisex t-shirts don't fit most women well, despite the name) or how many of each kind were needed.

In other situations, it's just that the user and the customer aren't the same. For example, SuperAmazingDoorCo doesn't sell its doors to the people who use them to enter and leave buildings, it sells them to the owners of buildings. That customer might be happy with the doors, as they are sturdy, reliable and cheap. Or the architect prioritized stylish doors, or glass ones that allow more natural light, over easy-to-use ones. It's only if that customer is motivated to care about the people who actually use the door, or the software, or the public transportation system, that things will change.

In other situations, we are a **captive user** or **captive customer,** meaning someone who has no other choice. If we

work in a building with a Norman door, or go to visit family in a city only served by one bad airline, what recourse do we have but to use them? And as Laura Ballay, former director of Carnegie Mellon University's Master of Human-Computer Interaction program, explained once in an online discussion we shared, "Business goals and user goals are often two very different things." For example, Intuit, makers of TurboTax, is motivated to persuade the US government not to improve its tax forms, as that would hurt sales of their product.[3]

Often, hotel showers or the kiosks in pay parking lots have confusing designs because those businesses know it's not worthwhile to invest in higher-quality ones: people don't choose where to stay or park based on ease of use (it's mostly location and price). Monopolies, governments and bureaucracies can fall into the habit of not making good things, simply because there's insufficient skill, pride or competitive pressure to improve. It turns out there are many logical reasons, however sad they might be, for why good design isn't as common as we'd like.

Beyond design quality itself, organizations often convince themselves that their work is better than it is. They reinforce their unconscious incompetence. Some do this with language, for example, calling themselves "customer centric." But what does that really mean? There's no official measure of, or license for, customer centricity. It's just a label any organization can apply to itself at any time, without changing the quality of anything. And corporations, which are profit centric, are at best a balance between generating profits and satisfying customer needs.

A telling example of that balance is what happens when an organization makes you wait. This could be at a doctor's office, a store checkout line or when you are put on hold when calling

customer support. They know exactly how much it costs to hire another person to reduce waiting times, but they've chosen not to spend it. Perhaps they don't think you'd be willing to pay more for better service, or they just want more profit. Either way, all too often, claiming to be customer centric is a kind of **design theater**: it's just for show.

3

WHAT IS GOOD?

WHAT WOULD THE best hammer in the world be like? Maybe you think it's Thor's hammer, Mjölnir, which flies into his hand whenever he asks. Or perhaps it's a high-tech, voice-activated and power-assisted Bluetooth model, which counts how many calories you burn for each nail that you put in. But this raises a challenge: Thor's hammer is for war. It's designed to be a weapon, with a heavy weight to maximize damage. It'd be tough to use it to build a house. And that Bluetooth model would require electricity to work. It wouldn't be very helpful if you were stranded on a remote island. It turns out there are hundreds of different designs for hammers, from the small to the gigantic, as artist Hans Hollein expressed in the amazing image below.

This means we can't really say that something is well designed unless we identify what it's going to be used for. The same exact hammer, or mobile app, or law, can be either good or bad, depending on which problem we are trying to solve. The very same object can be thought of as both a fantastic survival hammer and, say, a terrible bread knife or a

horrible Frisbee. It's easy to think a thing being "good" or "bad" is intrinsic to the thing itself. We often say "this is a good couch" or "these are great shoes," but this is a dangerous line of thinking for people who make things. It assumes goodness and badness are defined by the thing, rather than by what the thing is used for.

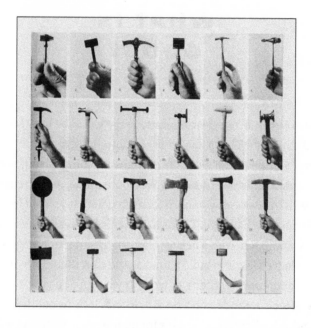

Good designers ask two questions throughout any project to make sure the context is well understood:

1. **What are you trying to improve?**
2. **Who are you trying to improve it for?**

Asking the first question (which sometimes takes the form "what problem are you trying to solve?") forces everyone to clarify the goal. If we don't explicitly discuss the goal, we

assume it is good and everyone has the same one in mind. That can lead to a **goal mismatch**: where different people on the team are working toward different goals. Perhaps someone thinks they're designing a war hammer for the battle of Ragnarök, but the problem that needs to be solved is slicing bagels for the weekly staff meeting (where one hopes no battle takes place). Or it could be as simple as one person believing the mission is to improve durability but another is trying to lower costs, goals that are likely at odds with each other. Eventually, smart organizations learn how good designers are at discovering these problems early on, when they're cheaper and easier to solve.

The second question is just as powerful. The designer of the Notre-Dame fire system assumed the guard would be someone who knew what ZDA-110-3-15-1 meant, which was not the case. This seems like an obvious mistake to us, but we didn't do the work. When your job is to both design and build, it's easy to get lost in the challenging work of building and forget the needs of the people you're doing all the work for and how much less about the details of the problem they will ever understand than the builder will.

The improved door shown in chapter one is a more interesting example. It seems like a good solution at first, but are we designing for people in wheelchairs? Or who only speak Hindi? What about people who are very short, tall or wide? Or have arthritis in their hands? Or are carrying a stack of hot pizza boxes while looking at their mobile phone?

This all means we should **resist judging how good or bad an idea is until we clarify the problem to solve and who we are solving it for.** Of course, it's convenient to not bother doing this. Who wants more work? Answering questions takes time. But skipping this step will leave you guessing about

what *good* means. Sometimes guesswork in design is fine, like if you're building a sand castle on the beach or making chocolate chip cookies without a recipe. If things go poorly, the stakes are low. But no one wants their artificial heart or the brakes in their car designed by guesswork—or the banking application they use to deposit their paycheck, or the airline website they use to book their family vacation (not to mention the airplane itself).

For fun, let's say that SuperAmazingDoorCo has a change of business strategy. They decide to become more design mature, integrating design tasks into their decision-making. They hire a researcher to quietly observe and study people using their doors in different buildings. They learn about the confusion their doors create and wisely take responsibility (instead of merely accusing their users of being stupid, a cop-out bad designers often use). They realize that a better design is a business opportunity, a way to improve sales and compete with other door companies.

They decide on criteria, or requirements, for what a good door is, listing the most important problems and goals to solve. The list would look something like:

1. Easy to install
2. Sturdy and reliable
3. Appealing, in style and price, to building owners
4. Easy for most people to use for basic door tasks
5. Made from sustainable and reusable materials

This list improves the odds that SuperAmazingDoorCo makes better doors. Every person who worked there could think about their tasks for the day and compare them against the list, making sure the tasks helped with one or more of the

goals. If the Notre-Dame fire system had a goal that said "make it easy for inexperienced and exhausted guards to immediately identify where fires are and take the correct action" the resulting design would have been much better.

But this doesn't go far enough. What does "easy to install" or "basic" actually mean? Without asking more questions, there's too much room for interpretation and design theater becomes likely. Easy could mean it takes thirty seconds or thirty minutes, the difference between a minor disturbance and a catastrophe at Notre-Dame. And what are basic door tasks? Is it just opening and closing, or does it include holding the door open for someone? Is walking with coffee a basic task, or carrying a small child? Once you commit to good design and start thinking clearly, another layer of questions is always revealed. This is good. Good questions lead to more good questions, just as good thinking leads to more good thinking.

Our two questions mean that terms like *user-friendly* or *intuitive* are as flawed as *customer centric*. They don't mean anything without context, and used generically they're another form of design theater. And design theater can show up in unusual places. Take, for example, this bottle and how it describes itself to potential customers.

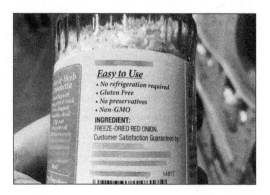

While grocery shopping I was surprised to see the phrase "Easy to Use" on food packaging at all. It's strange at first to think of foods being hard or easy to use, but our survival has always depended on the design of food. An apple has edible natural packaging, fits in one hand and the less enjoyable parts are conveniently tucked away in the middle. Most of the packaged food in supermarkets has been cooked or processed to make it more convenient to eat. Compare this to a coconut or pineapple, which require tools and effort to make edible at all (an artifact of their own design goal of reproduction, as the hard shell of coconuts cleverly protects the insides from impact when they fall, and from animals after they land).

Even so, it's strange to employ "ease of use" as a sales tactic for, of all things, dehydrated onions. More galling is that none of the facts listed have anything to do with usability at all. First, all forms of onions last longer in a pantry than in a refrigerator, so that first bullet is a deception. Second, having no preservatives might be good for your health, but it's an attribute of the onions, not of how they are used. In truth, the two most easy-to-use aspects of these onions aren't even mentioned: first, that they are diced and ready to go, and, second, that, since they're dehydrated, the fumes onions release that make us cry have been eliminated!

This is mostly just bad marketing, but that's the point: "easy to use" is a marketing term more than one good designers use. Ease of use can be measured, but only by comparison: time to complete a task, frequency of errors people make and success/failure rates are common criteria, but someone has to do research and measurement to justify these claims. "New and improved" is another common marketing cliché: being new doesn't guarantee something is good. And if it's

improved, it could just mean that it has progressed from being terrible to being slightly less terrible, which isn't much of an achievement.

A similar word is *intuitive*, which means a design is natural for people to use. The problem is that, unlike spiders or snakes, which enter this world with abilities like web spinning or slithering built into their brains, humans aren't born with any notable skills.[1] We can't sit up, talk or walk for weeks or months, and don't do these things well for years. What we call "natural" depends on an accumulation of what we learn through culture.

For example, a car steering wheel feels intuitive today because cars have been popular for a century, and we've seen them used in movies and on TV. But if you had a time-travel machine and handed a steering wheel to the Notre-Dame cathedral builders in 1163, or to the neural implant cyborgs in 2855 who have direct neural-Matrix interfaces, they'd have no idea what it was or how to use it. It would be definitively non-intuitive. This extends to the meaning of even trivial-seeming design choices in the present. The color red means danger or difficulty in Western countries ("red tape," "in the red"), but means joy and happiness in much of Asia. And the "thumbs-up" hand gesture is a positive sign in the West but is the equivalent of the middle finger in West Africa and the Middle East.[2]

We often fall into the trap of calling something intuitive if it makes sense to us, and call it hard to use if it doesn't. This assumes that everyone has the same knowledge and culture (ours!). It's an understandable trap: we are primarily emotional creatures. Frustration and delight are intense experiences that supersede logic. If we hold a prototype of a

new mobile phone or video game controller in our hand and it feels natural, that positive feeling outweighs the desire to ask "how is my hand different from other people's hands?" or "how can someone with no hands at all make use of this?" Asking those healthy design questions puts our own sense of pleasure at risk, forcing our emotions and our reason to be in conflict.

Thor has supernatural strength, so for him lifting his hammer feels easy and natural. Until he watched someone else try, and fail, it'd be easy for him to forget most people are not like him. Powerful people like executives and politicians often forget how distant their daily life experience is from what their customers' and constituents' lives are like. It's no wonder so many things in life seem perfectly made for the people who made them, and few others.

4

PEOPLE
COME FIRST

AT THE AGE of sixty-two, successful entrepreneur James W. Heselden fell from a path along a high cliff to his death. When it happened, he was riding a device called a Segway, a kind of electric scooter, and he fell as he was trying to move out of the way to let someone else pass. Heselden was the owner of the company that made Segways, but they were invented by a man named Dean Kamen. Segways had several design problems, but the strategic mistake that led to those problems was Kamen's decision to start working from the technology first, without studying the people he imagined would want to buy the invention.

Kamen had previously made many important medical inventions that helped millions of people. One of them was a wheelchair called iBOT that could travel over difficult terrain, and help people with limited mobility reach high shelves and get into tight spaces. Kamen started the Segway project with the goal of technology reuse: it was a technology in search of a new problem. Since the original technology was a kind of transportation device, it was natural to dream big and aim for

something everyone could use. But this was wishful thinking. To design something "everyone can use" makes big assumptions about different people's needs, and guesses that they are the same.

The prototypes of the Segway were fun. They felt like a powerful toy. The unique engineering meant the machine always kept its balance and effortlessly let you move at speeds faster than you could walk. It felt like floating above the ground on a powerful futuristic machine. The Segway demoed well, but in a demonstration, the maker can show what the product is good at doing, and that's not the same as showing how it solves a problem people want solved.

Kamen's reputation, combined with the working prototypes, led to grand promises for what the Segway would do.[1] He claimed it would "be to the car what the car was to the horse." Many luminaries were equally impressed by the

idea of the Segway. Steve Jobs said, "It's as big a deal as the PC." Jeff Bezos offered that it was "a product so revolutionary, you'll have no problem selling it" and John Doerr, an early investor in Netscape and Amazon, said it "may be bigger than the internet." More dangerously, the Segway's supporters accepted Kamen's definition of what the problem was ("replace the car"), forgetting to ask who it was really for ("who wants their car replaced, and why?").

This created a blind spot for the project. They were *building* more than *designing*. It's true that many great inventions begin as technologies first. But eventually someone studies the other perspective: Who will use this? How can we refine it to improve their lives? Had he started by studying people, or at least periodically switched focus, Kamen would have realized a better target to study was the bicycle, not the car, as far more are made and purchased each year (twice as many, in fact, at the time that the Segway was released: in 2003 there were about a hundred million bicycles produced, compared to about forty-two million cars).[2] A bicycle was cheap to own, easy to maintain, could carry an additional person or cargo, and was familiar to most of the population of planet earth. The Segway was none of those things. It was heavy, dangerous (George W. Bush and Piers Morgan also had serious Segway accidents) and strange looking.

Unlike a bicycle, powered by people's own legs, the Segway needed a charger, it needed its own service centers for repairs and it wasn't weatherproof. Even if it was going to solve some problems for people, it still created many new ones. Altogether, the failure to understand people's real needs explains why the Segway was a bust in the marketplace, finding only niche uses. Even if Kamen had combined thinking

from the technology first with thinking from the person first, doing due diligence from both perspectives in turns, the result would have been far better.

A good example of starting with people first is the story of the seven Jacuzzi brothers. They were an immigrant family of engineers from Italy who, after first picking fruit in California's orchards in 1915, made airplane propellers, hydraulic systems and eventually even airplanes. A crash of one of their aircraft killed one of the brothers, and the family shut down the company, shifting instead to making irrigation systems for farms.

In the 1940s one of the brothers' children, Ken Jacuzzi, was diagnosed with rheumatoid arthritis, a painful condition that required frequent trips to the doctor for hydrotherapy treatments. Ken's mother, Inez, suggested to her husband Candido that he use his engineering knowledge to solve the problem for Ken. Why not build something so he could do these treatments at home, with a portable hydrotherapy device?[3] Candido took her suggestion and designed a simple, suitcase-sized tube, with a non-Norman door–like handle on top, that could be submerged into almost any household tub, converting it into a hydrotherapy pool. Soon, hospitals wanted them, and soon after, the hot-tub craze in America was born, elevating the Jacuzzi models of hot tubs to the high end of the mass market.

By starting with one real person, and one real problem, you're guaranteed to satisfy a real need, without getting lost in the challenges of building or hubris. And if you can't solve one real problem for one real person, it's a good indicator that you probably can't solve a problem for millions of people, either. And, of course, if the goal is to solve a problem for

millions of people, you'll need to study far more than just one person's needs.

Many other successful products have a similar story of starting with people first. Westye Bakke, the founder of Sub-Zero, was in part inspired to make a more reliable refrigeration system to keep his son's insulin at the proper temperature, something existing models couldn't do.[4] It's well known that the Oxo line of kitchen tools, designed by Sam and Betsy Farber, began in an attempt to make cooking easier for Betsy, who had arthritis. It turned out their designs weren't just good for people with that condition, they were also good for anyone with hands. Even the Swiss Army knife, as its name suggests, was made for the specific needs of Swiss soldiers. After World War II, American GIs, inspired by how well the multi-tooled "knife" worked, brought them home and created the largest market the makers would ever have.

Our two important questions—what are you improving, and who for—are easy to ask. But there are many bad ways to answer them. The common mistake is to assume that you can think your way to answers. "I think people who use my product really need..." But that's just guessing, and when we guess, all of our worst biases, biases for the ideas we already have, biases toward solving our own problems, and biases to avoid doing more work, lead us astray. An honest designer knows they have to invest in time listening to customers, quietly observing them as they do their work, or testing early design prototypes, to understand what the real needs are.

People with ambition can be terrible listeners. They're often just waiting for the other person, even if it's the person they're designing for, to stop talking. They have so much misplaced pride in their idea that they believe it will

be instantly more valuable than whatever the other person just said. Rather than making a serious attempt to learn more about people to inform their thinking, listening is just an item on a checklist to allow them to say "we talked to customers" before approving the idea they had all along. Perhaps the most dangerous kind of design theater goes on in the designer's own mind.

5

EVERYONE DESIGNS SOMETHING

SINCE THERE ARE many different kinds of things, it follows that there are many different kinds of designers. Some are specific to an industry, others focus on an approach that can be applied to almost anything. Some common kinds of designers include:

- **Urban designer:** cities and neighborhoods
- **Architect:** homes, buildings and large structures
- **Interior designer:** the inside of places where people live and work
- **Game designer:** video games, and board games, too
- **Fashion designer:** fancy clothes, uniforms and what you're wearing now (even if it's not fancy)
- **Industrial designer:** physical products, like toasters, automobiles or anything that's manufactured
- **Graphic designer:** visuals for magazines, street signs, logos or websites
- **Web or mobile app designer:** internet sites and mobile applications

As you might guess, this list could go on forever. Sound designer (films and concerts), boat designer, service designer (customer experience at a restaurant or hospital), slaughterhouse designer, fire alarm designer, prison designer, election ballot designer (the butterfly ballot!), roller coaster designer, and on it goes. Some professions prefer the word *engineer*, like aeronautical engineers, but they describe themselves as people who "design... aircraft, spacecraft, satellites, and missiles."[1] This list also doesn't include professionals like carpenters, chefs and teachers, who spend some of their time designing things (shelves, meals, classes), even if they don't use the word *design* often.

Similar to doctors and lawyers, different kinds of designers share some common knowledge, but the specializations diverge widely. For example, while both cardiac surgeons and dermatologists know first aid, you'd never ask a dermatologist to do double-bypass heart surgery on you (although you'd have a beautiful complexion in the afterlife). Similarly, you probably shouldn't ask a web designer to design a nuclear missile, or vice versa.

As we try to understand how design makes the world, user experience (UX) design is particularly useful. These are designers who don't focus on the object, like the website or the chair. Instead they study the person (aka user) first. "Who are we designing for? What tasks are they trying to accomplish?" UX designers make prototypes, and design user interfaces, ensuring the experience people have with what's made is as good as possible. They often work with UX researchers, specialists who inform decision makers about users and how their needs are being met (or not). They design and run usability studies, interview customers and use a powerful toolkit of methods to improve design decisions.

Even though design is a profession, every person in the world is a designer in some way. **Everyone designs *something*.** It might be the arrangement of furniture in a living room, or the placement of items on an office desk. Even arranging icons on the home screen of a mobile device or the background images for a social media profile are acts of design. They share the same elements of deciding on a goal, even if it's implicit and subconscious, and then making choices to fulfill it.

Of course, the result of what people do might be terrible, more like building than designing, but that makes them bad designers, more than non-designers. Everyone gets dressed in the morning, a design act, but some do it much better than others. It's unlikely for a person to go an entire day without designing something, in some way, much like writing, speaking or other common abilities some people do professionally.

Victor Papanek, one of the great heroes of design, had this to say:

> Design is basic to all human activity... any attempt to separate design, to make it a thing-by-itself, works counter to the fact that design is the primary underlying matrix of life. Design is composing an epic poem, executing a mural, painting a masterpiece, writing a concerto. But design is also cleaning and reorganizing a desk drawer, pulling an impacted tooth, baking an apple pie, choosing sides for a backlot baseball game, and educating a child.[2]

Designers often argue about how to define design and some don't like Papanek's definition. He blurs together art, which is about personal expression, with design, which is about solving problems. He also compares tasks like baking

an apple pie, which is mostly following a series of steps, with "painting a masterpiece," which is far more challenging. Yet I'm more with Papanek than against him. Everything he mentions is about a person with a specific intent, or idea, and who goes about trying to make it real. How creative it is, or isn't, or how beautiful or useful it is to others, is less important for now than seeing that there's something shared in many kinds of human activity.

To put it more clearly, our collective survival as a species is based on the ability we share to design things. About two million years ago, when we made the first stone "axes," literally just sharpened stones, we shaped a raw material into something that served our purposes.[3] This ability to design, and then teach others, is a hallmark of what makes us human. We can't say for sure, way back before we designed the first language, what we called our sisters and brothers who were better at designing axes, shelters, meals, clothes and tribes than the rest of us, but we all share an inheritance of design ability, otherwise we wouldn't exist as a species at all.

A major difference today between professional designers and ordinary people is how thoughtful they are in making decisions. Most people in their day-to-day life simply want to get things done with a minimum of fuss. They'll put the couch on one side of the room and the table on the other, and if it works OK that's just fine. Or they'll create a website or a social media profile using the simplest, easiest template, keeping all of the default options. Only if there is a problem will they consider an alternative. They feel that the return on investment for looking for better ideas is low.

Good designers, on the other hand, have a high bar for quality and thoughtfulness, both for their clients and, often,

for themselves. And they know that the only way to get high quality is to explore many ideas and compare them against each other, along with a criteria list of what is good, before making decisions. This is why designers are notorious for asking many questions. They want to deeply understand the people and the problem so that they can thoroughly evaluate several ideas. As the joke goes: How many designers does it take to screw in a light bulb? To which the designer responds: Does it have to be a light bulb?

This sounds annoying, and designers can come across that way. Yet the good ones know that most people jump to conclusions faster than they should (for example, maybe a better problem to solve is to redesign the room, or your daily schedule, so artificial light is rarely needed). Often, the biggest challenge is simply that the problem chosen isn't the real one, or has been defined in a shallow way.

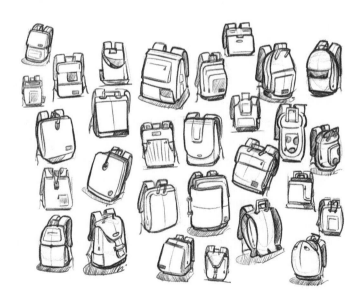

The first time most people work with a pro designer, it's a surprise how much time they spend exploring different possible ideas. It's not uncommon for a designer who's working on a watch, or a mobile app, or a toaster oven, to make dozens of sketches and prototypes, maybe even hundreds as they refine the details of how everything looks and works. Many people think, "well, if you're good at design, you should just be able to design me something good the first time." But to design something even as seemingly simple as a backpack, designers may spend hours exploring options and asking questions. They start with rough sketches, so they can try many ideas quickly, learning as they go, as the above sketch by designer Carly Hagins demonstrates.

Not only is picking the first option you come up with not how good design works, it's not how good decision-making works, either. Would you marry the first cute person you met? Or move to the first country you see in a movie? An analogy offered to me by designer Delaney Cunningham is to think about the last time you bought a new pair of shoes to match a specific outfit. Did you just walk into the store and grab the first pair you saw, without looking at the size, then buy them without even trying them on? Most people know that in order to find the right pair, they have to try many different designs, make observations and then refine their idea of what good is as they go. We also know that there is a **tradeoff** with shoes between the price, the style and the level of comfort they offer, and every pair is somewhere different in the combination of those three qualities. Buying shoes has a sequence of steps (ha ha) that you must go through to arrive at a good solution. Design works in much the same way. It's a process for finding and evaluating ideas to get good results.

Of course, buying shoes isn't the same as designing shoes. To make a pair of good shoes would require more work. But whenever you thoughtfully buy shoes you are going through a similar process of exploration and consideration of alternatives to what the designers who made them did.

The bigger challenge is when you are designing for someone else. Could you reliably buy a pair of shoes for someone you never met or had no information about? It'd be foolish to try. People's feet and what they find comfortable, or stylish, is personal. You'd need to study that person, including watching them walk and observing the activities they do all day (as what we say we do and what we really do are often different) before you'd have any chance of success. At best, you'd probably need to buy several pairs, so the person you are shopping for could learn and explore, and return the rest. Which is another good reason for starting with people.

6

THE STREET
YOU LIVE ON

FIRE ALARMS, DOORS, dehydrated onions and shoes are
good for learning about design, since they are scaled for us.
Even more interesting are designs that are so big you often
don't notice they're there. Things like cultures, neighbor-
hoods and even cities themselves. The quality of the places
where you live, work and play were shaped by designers long
before you first experienced them, but their impact is often
more profound.

NYC, where I was born and raised, is famous for its streets.
The central borough of Manhattan in particular is known
for its grid system of streets and avenues, which means
every intersection has right angles in every direction. The
first use of grids likely dates back to 2600 BC, in the city of
Mohenjo-daro, in what is now Pakistan.[1] The Greeks, includ-
ing Alexander the Great, reused the idea, and the Romans
applied it to Italian cities like Naples and Turin, collectively
spreading this concept of city design around the world.

This system is popular in America, chosen first by William
Penn for Philadelphia, but many cities in the world, like Paris,

London or Venice, are not based on grids. Instead, these cities developed organically into curved roads and non-uniform layouts. Is the grid system a good design? As is often the case, the best answer is "it depends"—that is, until we can ask our questions.

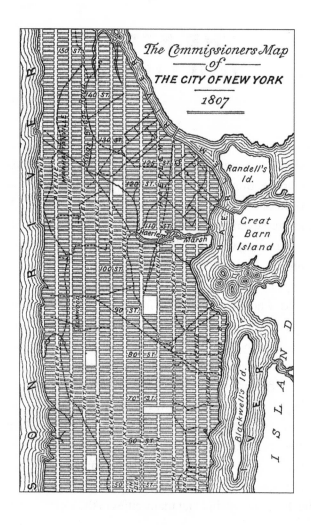

In 1807, when the grid for NYC was created, it was largely motivated by landowners who wanted a simple way to sell their land. Rectangular parcels are easier for potential buyers to look at and understand. Even so, it took a century of attempts, all derailed by power struggles between landowners and the city government, before the 1807 committee finally succeeded in coordinating enough authority to redesign the city.

The grid is also a good system for pedestrians and tourists. It's simple for people to find their way around, since streets and avenues run parallel to each other. Even if you turn the wrong way, it's easy to recover, since right angles at every intersection ensure you never go far without another set of streets reminding you where you are. Grid systems are good for retail businesses like hotels and restaurants, since grids have corners, and corners are visible on two different streets at the same time.[2]

However, if you walk, bike or drive a car, the grid guarantees you'll stop at more intersections (this depends on how large the squares formed by intersecting streets are, but most urban grids have small blocks). Grids are also expensive to maintain, at least in modern times, as the number of traffic lights, pedestrian crossings and related infrastructure are higher. Lastly, grids pay no attention to the landscape, so hills, lakes, forests and other natural features aren't easily accounted for.

Anyone who has to walk on the steep hills of Pittsburgh or San Francisco has to wonder if the grid was the best design for some parts of town. Grids do create beautiful views on dramatic landscapes, but at the price of making it hard to get around. Lombard Street, among the steepest in San Francisco at a 27 percent grade, was made into a series of tight

switchbacks, breaking from the grid, precisely to make it safer to use.[3] Yet the actual steepest in the city is Filbert Street, at a 31 percent grade, which loyally follows the grid without regard for your knees. The steepest residential street in the world is Baldwin Street in Dunedin, New Zealand, at 35 percent. It was designed this way, on a grid, by city designers in London who didn't bother to study the landscape, or didn't care.[4] If you look around where you live or work, you'll notice some similarly curious, or incompetent, urban design decisions.

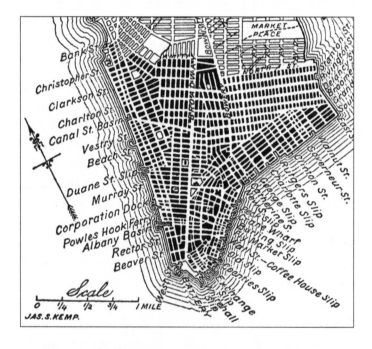

The 1807 plan for NYC left the oldest part of the city, at the southern end of Manhattan, untouched. Older cities have more organic designs, since streets were added gradually and

not as part of a master plan. For many, south Manhattan is their favorite part. The diverging avenues and angular streets give neighborhoods like Greenwich Village their charm. Famed urban design critic Jane Jacobs disliked the grid plan. She preferred Greenwich Village's layout for how it created a more community-oriented experience. It was more comfortable to be outside, with wider and quieter sidewalks than other parts of the city. The smaller and less uniform block sizes let each one have its own character and charm, unlike the monotonous repetition in the rest of Manhattan. She'd have loved the backstreets of Kuala Lumpur and the laneways in Melbourne for similar reasons.

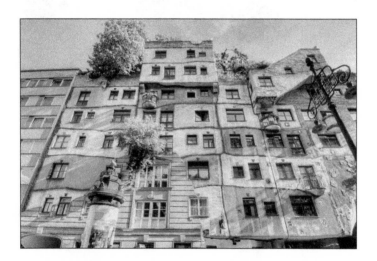

The German architect Hundertwasser, who avoided right angles whenever possible in his creations, said, "The straight line has become an absolute tyranny... cowardly drawn with a rule, without thought or feeling; and the line is the rotten foundation of our doomed civilization."[5] I can't say I feel that

passionately about any geometric shape (except for the parallelogram, which is just fun to say), but it's true that part of why we find walking in nature relaxing is that there are no straight lines. Even trees, which children often draw at a 90-degree angle to the ground, always curve and bend as they grow to capture the light. Hundertwasser hated straight lines so much that none of his buildings had any, except where they couldn't be avoided (windows, walls and floors). His Hundertwasser-haus in Vienna is delightful to look at, even from the outside.

A similar idea is reflected in how the streets and canals of Venice evolved. Even though right angles make things efficient, there are other choices that can have similar effects. Many good designs found in nature, like the fractal veins on the leaves of a tree or the way rivers gracefully bend through valleys, don't use right angles, either. The grand

canal in Venice curves through every part of the city, ensuring that, as architect Paul Jacques Grillo explained, "Like nerves and blood capillaries, streets and canals of Venice bring life through all parts of the city, and in this square mile of dense building, from the Grand Canal, no spot is further than a thousand feet, or a few minutes of gondola time... The Grand Canal in a superb S, is Main Street, but three times longer than modern engineering would have made it, making it close to all parts of the city in ever changing perspectives."[6]

The natural world has many reusable ideas for us. Evolution and natural selection represent millions of years of design advancements, just without a designer. Biomimicry is the study of nature to find reusable ideas, but we've done this instinctively before it had a name. The invention of Velcro by George de Mestral was based on how cocklebur seeds stuck to his dog's fur during hikes in the Swiss Alps. Many winged insects have a gearbox, a veritable transmission, that controls their rate of speed, and have had them long before Benz or Ford attached one to their first cars. And of course insects and birds were flying for millions of years before the Wright brothers were born (and the brothers studied many flying animals in making their first prototypes).[7] Even Tokyo's famous Shinkansen bullet trains, which travel faster than three hundred kilometers an hour, have a shape based on aerodynamics learned from the kingfisher bird.[8] Our most modern inventions often depend on concepts that predate our very species.

As Beatriz Colomina and Mark Wigley report in *Are We Human? Notes on an Archaeology of Design*, "The average day involves... thousands of layers of design that reach into the ground and space but also deep into our bodies and brains... the planet itself has been encrusted by design as a geological layer... design is what you are standing on. It is what

holds you up. And every layer of design rests on another and another and another. To think about design demands an archeological approach. You have to dig."[9]

Next time you're on your own street, stop for a moment. Give yourself time to observe the designs you typically move through many times a day without thinking about. You likely don't notice the choices made by others that have a profound effect on your life.

- Is it easy to walk to places you need to go often?

- How is your neighborhood designed for cars? Or for people?

- Are there shared spaces, like parks, nearby? Or is everything exclusive?

- What is your favorite route to get to/from home? Why? What route do you avoid?

- Is it natural to meet neighbors when you want to, or do you rarely see or talk to the people who are closest to you?

- What does it sound like on your street? What choices make it this way?

- What patterns repeat? What choices have charm or character?

- Who made all these decisions? What were their goals?

7

STYLE IS
A MESSAGE

IMAGINE YOU ARE walking down a busy street in Seattle on a lovely sunny summer afternoon. It's been a long day and you're hungry. You've heard that both Thai and Vietnamese cuisines are excellent in Seattle and you look for a place to eat lunch. You discover two choices nearby. How would you pick which one to go to? The first one looks like this:

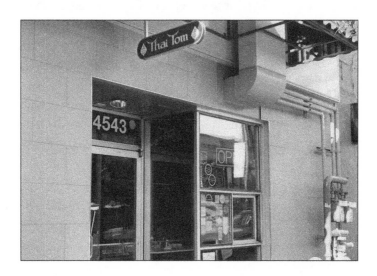

And your second option:

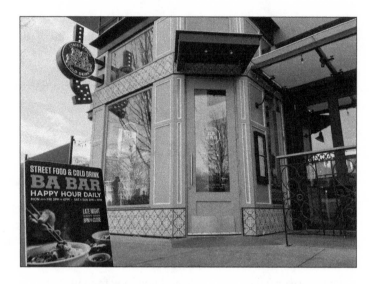

Immediately, your mind would have feelings about both places, based on how they look. If you broke it down into details, and studied these storefronts like a designer would, many questions would arise. Does it look clean or dirty? New or old? Does it look fancy, suggesting a more expensive, upscale experience, or clean and simple, suggesting fewer frills but more affordability? Is there a daily special, suggesting a more adventurous chef, or a regular meal-deal, pushing consistency and reliability? Before you ever step inside, how the outside is designed directly impacts your opinion of the totality of the organization.

Designers are often trivialized as people whose job it is to "make things pretty," but this is a mistake. It assumes that function always matters more than appearance, and that style is a recent luxury in our history. There's evidence that

the opposite is true. Some early axes made by Homo erectus were refined well past the point of utility, with the added goal of making them look good, perhaps to attract a mate, or to demonstrate trustworthiness or social status[1] (whereas today, most of our status symbols are purchased, not made). We've also found extensive use of decorative sea shells and red-colored pigment, designed objects created by hand over 200,000 years ago for style purposes, purposes that likely also included distinguishing between friend and foe.[2]

The idea that style is secondary also denies a truth about how our brains work and what drives our decisions. It takes less than twenty milliseconds for our brains to recognize and process an image.[3] Our brains take in volumes of visual data, far more than we can consciously process, meaning our behavior is influenced in subtle ways, often in first impressions and feelings. Even something as simple as the taste of food changes depending on how it looks: studies show that people struggle to recognize certain flavors, like lemon or strawberry, if they eat foods blindfolded.[4]

This means that every designed thing in the world, from fashionable shoes to urban street signs to an organization's website, sends messages to everyone, influencing their mood, their level of interest and the way they make decisions. This is true in even the smallest interactions, like deciding which app to buy from an app store, where the design of a tiny 120-by-120-pixel icon defines which will be purchased and thrive and which will be ignored and go out of business.

Even if you don't care how you look, and wear the same worn-out and possibly ill-fitting unisex t-shirt and jeans every day (even though you have the means to buy other outfits), you still choose to own that particular style of shirt and pair

of jeans. It wasn't an accident; you chose them. As the famous scene from the movie *The Devil Wears Prada* explains, a fashion designer made those items at a specific level of quality, to be sold at a specific price, with you as the person they believed that design would appeal to.[5] And even if you pick your clothes at random, truly feeling that your appearance doesn't matter, how you look sends a message to everyone you meet, the message of "I don't care how I look," which is a kind of statement, too. (Something to keep in mind on your next first date.)

In the case of those restaurants, there is more to the story. Thai Tom has been a fixture on that street, near the University of Washington, for many years. It's a tiny place with room for maybe twenty people, and it's often packed. It has an open kitchen, and it's exciting to watch the hardworking cooks making your food just a few feet away. They have fast service, a good reputation and loyal fans, regardless of how simple the exterior appears. It would be hard to know all this, as there's no sign out front explaining their story, but it's well known anyway. They're a cash-only place and seem to spend little on marketing or advertising. They do well with their repeat customers and the word of mouth that gets spread to new ones. There is often a long line outside before they open, a signal of social proof to others that it's a meal worth waiting for. They don't seem to be worried about the messages their storefront sends to new customers, which is a kind of meta-message all on its own.

The second restaurant, Ba Bar, is newer and located on the edge of a high-end outdoor mall. Unlike a street near a university, where most of the possible customers are college students, Ba Bar is catering to a relatively affluent audience,

and to people who are not in a rush on their way to class. They're trying to solve a different kind of design problem than Thai Tom is, which helps explain why they look different. Could Thai Tom generate more business if they changed how the outside looked? Hard to say. Their regular crowd might take style changes as a message that their favorite familiar place isn't the same anymore.

Visual messages are heavily influenced by culture, which means sometimes the message the designer intended to deliver goes unnoticed or gets confused with a different message. Most Westerners today think of the swastika as a symbol of evil, as they learned of it because of Nazi Germany. But the Nazis stole the symbol from older cultures, and changed its meaning. For ten thousand years it was a symbol for things like luck, rebirth and spirituality in Hinduism, Buddhism and other older cultures and religions. Before World War II, products like Coca-Cola, Carlsberg and Boy Scout badges used swastikas in their ads.[6] If you travel to India, China or Japan, the symbol is still commonly used to mean good luck, like a four-leaf clover.

Thai Tom might look bland to a tourist expecting something bright and new. Then again, cost matters most for some, so the message of "expensive and upscale" is a negative one. Still others like adventurous dining, so a place that's less inviting, perhaps where much of the menu isn't in English, is far more intriguing. Author and chef Anthony Bourdain was famed for his preference for family-owned and less pretentious places to eat, as they provided better food and more interesting experiences. These establishments are often in less convenient locations, since it's more affordable, and closer to where their best customers live.

The messages that different styles convey aren't just a property of large things like restaurants or grid plans. This aspect applies to even the smallest decisions we make. For example, if you needed to write a letter to let your good friend know that their beloved Great Dane/Rottweiler mix named Nibbles didn't survive his kidney transplant, would you use a friendly, fun typeface like Remedy OT?

Sorry my friend, but Nibbles didn't survive.

Or something more staid and traditional, like Garamond:

Sorry my friend, but Nibbles didn't survive.

But what if your message was positive and exciting, instead of sad? The same choices have a different feeling, as the messages the styles convey match, or contrast, with the content differently.

Here's our fun typeface Remedy OT again:

NIBBLES LIVES! Let's have a party tonight!

But, as is often the case with style, it's the careful combination of styles that truly matches the implicit message with the explicit message you wish to convey:

Nibbles lives! Let's have a party tonight!

It's easy to think of typefaces as another kind of "make it pretty" choice that can be made last, after everything else is done. But in many kinds of design it's such style choices, and the message you intend to send to people, that have to be

made early. As a general rule, the decisions you make first on a project have the most freedom, and the decisions you make last have the least. If style and the message it sends is important, then, these choices must be considered from the start.

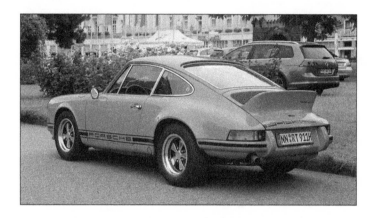

This is one of the most famous sports cars in history, a 1972 model Porsche 911. Notice the curves and lines of the car's body, and the spoiler on the back. These choices convey speed and high style. But building a car like this required these choices to be made early. If they were made later in the process, after the engine size was chosen and the frame, or underbody, was built, a design as striking as the 911 would have been impossible.

To drive (hee-hee) this point home, imagine that the team that designed the car was trying to solve the problem of building an affordable commuter car with great mileage. They would pick a small, efficient engine with little power, and a frame that was simple to build, with a box shape. By the time the exterior style designers got involved, their best ideas for a sports car would be impossible. The result would be a car that looked and drove more like this one.

This means that style can't be a last thought, unless style is unimportant. It also means that design, at its best, is a collaborative process. The engineers and designers who work on the engine, frame and exterior should all feel like they are working on the same team with the same goals, so the customer experiences a car that feels like it was designed by one very talented person with one vision. When the strategy for a new car is being developed, designers should be in the same room with the business decision makers and the engineering leaders. As a rule, the better designed a thing is, the earlier designers were involved in how that thing was made, and the more collaboratively they worked together.

When style is used in a consistent way that is paired with a purpose, it has effects more profound than simply sending a message. Consider the following image.

Pirates in the early 1700s used the Jolly Roger, also known as the skull and crossbones, to intimidate other sailing ships. Initially, pirates had many different flags, all with black

themes, but they naturally unified around this one symbol because of its effectiveness. It frightened their future prey, warning them of what was about to happen. And since pirates were primarily businesspeople (of the unethical variety), the more compliant their victims were, the better. As Tom Wareham, curator of maritime history at the Museum of London Docklands, offered, "If [pirates] terrorized a ship on approach, they could board it, get what they wanted with minimum trouble and walk off with the proceeds."[7]

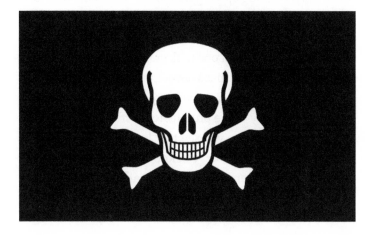

Today, as design critic Alice Rawsthorn explained in the *New York Times*, we call effective messaging like this "branding." Another term used for it is *identity design*, which means the intentional crafting of imagery to convey messages about an organization. The term *brand* itself comes from the literal branding of livestock with hot irons, which was primarily about proving ownership. But eventually this term came to be used in the longstanding tradition of tribal colors, and national flags. Long before pirates in the West started raising

the Jolly Roger, cultures around the world were using similar techniques, or at least had similar goals. Now, branding is something organizations and businesses have adopted as strategy. If a pirate flag can influence sailors on a boat miles away, what could a friendly flag, or logo, do to consumers? Seeing the Nike swoosh or the McDonald's golden arches has a powerful effect on most people, whether they realize it or not.

The challenge is that having a great logo isn't enough. Pirates didn't start by making logos: they started by robbing and killing, building up a reputation known around the world. (Their evil product, if you will.) Only then could the pairing of that reputation with a logo, or brand, be effective. It would be nice to think there's just one trick or method that makes quality design happen, but that's never the case. The McDonald's logo, like those of most fast-food corporations, works because of the consistency of the product (even if experts tell us it's not healthy). Anytime you see that logo, even if you're five hundred miles from home, you know exactly what the experience of eating there will be like. That's why it works: the brand, the product and the expectations all line up together.

8

DESIGN IS
HOW IT WORKS

IMAGINE IT'S 2:06 P.M., and you're late for your 2 p.m. meeting with your punctuality-obsessed boss. You work in the Burj Khalifa in Dubai, among the tallest buildings in the world at 828 meters (or 2,717 feet) with 163 floors. Due to its tubular structural design, it uses only half the amount of steel that the Empire State Building does (at 381 meters tall). You bemoan these facts as you run down the long hallway to wait for one of the tallest elevators on the planet. Luck has favored you: the door is open, the car is empty and you jump inside. You push 152, for your boss's floor, and wait. But the door doesn't close. Not right away. You find the "close door" button and push it. Then push it again. And then one last time, and to your relief the door closes and you're on your way.

The surprise is that it's likely the button you pressed didn't do anything, except light up. This is what's called a placebo button. There are many kinds of these buttons in the world, including office thermostats and urban crosswalks in many cities that have buttons for pedestrians to "tell" the light that they want to cross.[1] In 2004, it was estimated that only 20 percent of the 3,500 buttons throughout New York City actually worked. The reason is simple: it's not worth the cost to connect and maintain them, since most people typically don't notice the difference. For elevators in the US, the motivation was the passing of the 1990 Americans with Disabilities Act, which required doors to stay open long enough for people on crutches or wheelchairs to get inside.

Your expectation for what a button, or anything in the world, does, or how you believe it works, is what's called a **mental model**. In many cases the mental models we have for how things work is shallow, or even wrong. For example, many people think evolution is a progression from inferior creatures to superior ones. The more correct model is that the creatures best suited for the current environment tend to survive, even if they are dumber, slower and "inferior." For example, a warmer planet will help some creatures thrive, like starfish and octopus, and make survival harder for others (hint hint).

The term *mental model* comes from cognitive psychology, which is the study of how our brains perceive, think and interact with the world. Some designers are trained in how to use this knowledge to make better design decisions. Related to elevators and waiting for things, it's well documented in psychology studies that most people, most of the time, like to feel in control of things, including elevators. (The degree to which you have this feeling is called the "locus of control.")

Studies have proven that when we think we're in charge, or at least actively doing something like pushing placebo buttons, our sense of how much time something takes is reduced.[2] In general, good designers study the limited mental models that people have, as well as the more accurate ones, and create ways to navigate the gaps.

A classic lesson in using mental models to improve a design is the possibly apocryphal story of how one of Houston's airports designed its baggage system. After complaints about long waits, they hired more baggage handlers, which helped, but complaints still came in.

They decided to do something unusual. They routed bags to the farthest carousel from the arrival gates, which made the walk six times longer. This sounds at first like a mistake, but it meant that when passengers arrived at baggage claim, their bags would already be there. Complaints dropped to zero. Dan Ariely, in his book *Predictably Irrational*, explains how surprises like this are common in human nature, and that science can explain the real factors that influence our opinions and choices.

It seems counterintuitive to design for irrationality, but people are rarely as rational as we presume. "Often the psychology... is more important than the statistics of the wait itself," said MIT operations researcher Richard Larson,[3] one of the world's top experts on the psychology of waiting. The elevator you ran to catch to meet with your boss likely had floor-to-ceiling mirrors in front of it, another technique that gives you something to do and makes the wait feel shorter. Disney's amusement parks are masterworks in designing for time perception: they show estimated waiting times to reduce anxiety (something elevators should do), but they also

overestimate those waiting times, so customers are happily surprised.[4]

Such knowledge of psychology, and even the biology of how our bodies work, can be used against us, too. The professions of marketing and advertising depend on manipulating this knowledge. Take fast food, for example. We know that eating milkshakes and cheeseburgers every day, although tasty, won't help us live long, healthy lives. But our brains crave sweet, salty and fatty foods, so we're tempted. In our evolutionary history, these tastes signified large sources of calories, which were rare.[5] We've survived for millions of years because of these cravings and our ability to store calories as fat to compensate for days when we couldn't find anything to eat at all (we were all once intermittent fasters). Today, designers of advertisements use those cravings to tempt us to eat things that work against our very health.

Here's the trap: at the moment we decide to buy another cheeseburger, or donut, or cheeseburger between two donuts, we're evaluating only the most superficial elements of what the design of a cheeseburger is. The mental model for preferring these things dominates, since it's fueled by our ancient genetics. And the advertisements are designed to play on that model. Perhaps they show freshly made French fries, with crisp brown edges, flying in slow motion through glorious clouds of shimmering salt flakes, or grill-marked burgers cooking over a roaring charcoal fire. The temptation in these experiences makes it easy to forget, or ignore, that the primary purpose of food is to sustain us, not just entertain us.

It's not only the advertisements: the food itself is designed, too. A century and a half ago, most things we ate came from natural sources, without much processing, but today food

in the West is more engineered, or designed, than grown.[6] Through the profession of food engineering, salty, sweet and fatty flavors are cheap to produce, stripped of the nutrition that was in the whole foods they came from. Engineers create flavors with the intent of stimulating our cravings beyond how natural foods can, and doing it in the cheapest way possible.[7] Our bodies, using the same digestive system design we've had for thousands of years, know that something is amiss. But when the food is so cheap, and provides the most intense sweet, salty and fatty flavors, it's hard to resist (and in some neighborhoods there are few alternatives). And afterward, with our bodies still left unfulfilled, the true model for nutrition having been ignored, we're drawn right back into the same mistake.

When we look at something, whether it's a cheeseburger, a storefront or a website, we're wired to consider the most superficial elements first. We read the messages from its style: how it looks and how it makes us feel. We buy shoes and clothes often because of how they look, even if they're not the most comfortable to wear. This is often fine provided we're aware of the tradeoff we're making. "I don't mind being uncomfortable for an evening if I will look this good." Or, "I'm drinking a bottle of good wine and as many double-decker BLT burgers with grilled cheese sandwiches for buns as I want to celebrate my birthday." We are built for pleasure and should enjoy life when we can. The danger is that *design* is often used as a shallow term to describe just the surface, distracting us from what matters most. Consumer culture makes it easy to believe that the ideal life is a series of intense but shallow pleasures, rather than a balance with deeper ones. Think of what Apple founder Steve Jobs said:

People think it's this veneer—that the designers are handed this box and told, "Make it look good!" That's not what we think design is. It's not just what it looks like and feels like. Design is how it works.[8]

Thinking about how something works means considering the totality of what that thing is for, what role it will play in someone's entire life and its total impact on the world. Food and agriculture produce 24 percent of the world's greenhouse gas emissions.[9] What you choose to eat impacts not just your body, but also the system of life we all depend on. Advertising is designed to focus us on the emotions of the moment. It promises we will feel great and be loved in the present if we buy what's being sold. It deliberately turns our attention away from deeper questions, like: what regrets did we feel an hour or a week after the last thing like this we bought (or ate)?

This explains why many of the things we buy end up, often barely used, in storage bins, landfills or virtual trash cans. We mistake the delight we feel at the moment of purchase as a sign that the thing we've bought is going to have a long and positive impact on our lives.

There are many ways to think through the true design of something, and how it works (or doesn't work):

- **It improves your life now.**
- **It improves your life for years.**
- **It's simple or rewarding to learn.**
- **It works reliably and has lasting value.**
- **It's easy to repair and upgrade.**
- **It's safe for people and for the environment.**

Notice how rarely some of these attributes are the focus of how things are sold. They reflect a deeper way to think about what good means. Ironically, Apple products are notorious for being hard to repair, and for using materials that are dangerous for the environment. Steve Jobs himself had a limited view, one that benefited Apple, of what it means for something to truly work well.

The intent of placebo buttons like "close door" in an elevator and of fast-food cheeseburgers are different in comparison. While it's true that placebo buttons don't technically work in an engineering sense, the effect they have on people is a positive one, by design. The designer of a placebo button uses cognitive psychology to influence how people think and feel, but primarily does so for everyone's benefit. Since thousands of people share elevators, or city crosswalks, if each individual could demand immediate service at any time, the system would fail. The choice is to either allow people to feel time is passing faster, or not to. Of course, a better functioning design (perhaps an estimated wait time display, that gives better feedback than simply lighting up a pressed button) would be better than a placebo, but a well-designed placebo is better than nothing.

Alternatively, fast food and its carefully constructed advertisements manipulate people's instincts to buy and eat things that in the long term have detrimental effects on their quality of life. As a source of hedonistic pleasure, we could say eating a double cheeseburger and milk-free "shake" for dinner works well, but if we're thinking about having a long and healthy life, consuming them as much as their makers would like us to doesn't work at all.

9

SOMEONE
HAS TO PAY

IN 1952 NILS IVAR BOHLIN, a mechanical engineer and airplane designer, was working on ejector seats for pilots. These seats had to safely withstand a g-force of 12 and respond instantly to crisis, but without harming the pilot. He worked for Saab, which at that time was known more for airplanes than automobiles (much like BMW, whose logo represents a spinning airplane propeller). In 1958, Volvo hired him to work on safety for a different kind of pilot: ordinary people driving their cars.

At the time, there were few safety standards for automobiles. Steering wheels were often made of metal, and one 1954 Cadillac model even had a bullet-shaped horn in the center (Sammy Davis Jr. lost his eye because of such a feature). Seat belts were not standard issue and those that did exist only went across the driver's lap, providing limited safety for the driver's head and upper body.

Bohlin spent a year working on a new design, studying what other inventors had done and experimenting with different prototypes. He rejected many ideas because they didn't

meet criteria he had in mind, which, put simply, was human nature. Bohlin once explained his design this way: "The pilots I worked with were willing to put on almost anything to keep them safe in case of a crash, but regular people in cars don't want to be uncomfortable even for a minute."[1]

Eventually, he arrived at a concept that would become the industry-standard three-point seat belt. It combined one strap that went over the shoulder with another that went across the lap into a simple single-lock system. An elegant touch was placing the buckle at the hip, an improvement from other three-point designs that Bohlin studied, which placed the buckle in the middle front of the seat. His goal was to design something that was "simple, effective and could be put on conveniently with one hand."

The problem was that car companies didn't want to pay for them, and consumers were not voicing demand. Automobiles were new and people loved them. There's so much optimism with new technologies, whether it's automobiles or the internet or self-driving cars, that there is rarely popular motivation to look for what new problems these inventions might create. It takes years for governments, and citizens, to understand the issues and make laws to remedy them (it took us over thirty years to realize cigarettes were bad for us).[2] We see this even today with how long it has taken to understand the downsides of social media and misinformation and mobile devices and distracted driving (and living).

Volvo made the three-point belt standard in their cars in 1959, but no other companies followed. Volvo even gave away the patented design for free in hopes of saving more lives, but adoption was slow, at least in the US. Two-point seat belts became standard in cars by law in America in 1968, and mandatory for drivers starting in 1984 in some states. Today, we know that three-point seat belts, which save fifteen thousand lives annually, are a good idea. As are anti-lock brakes and other safety systems that are standard in most cars, and people are happy to have them.[3] Why then was the adoption of these designs such a slow, frustrating process?

One answer is that it has always been hard for people with good ideas to find others willing to pay them. The romantic way the stories of creative heroes are told deceives us into thinking their ideas were so obviously good that everyone rallied behind them, but in truth that rarely happens.[4] It took years, or decades, to go from working prototypes to people adopting electric lights, copy machines, personal computers or mobile phones on a meaningful scale.

The success of people with ideas has always **depended not on their creative talents alone but on their ability to persuade**. They all needed to convince others to give them money to do their work. We know names like Georgia O'Keefe, Marie Curie, Chuck Berry, Paula Scher or I.M. Pei largely because they were able to convince other people to pay them. We take their creations for granted, but when they were doing the work they'd become famous for, persuading people to pay for and use their ideas was central to their success.

The car industry had a second chance to think about safety. A decade after the introduction of the three-point seat belt, other safety inventions, including air bags, were developed and market ready. But the industry balked again, citing the costs of these new ideas as prohibitive. In 1975, Lee Iacocca, the president of Ford Motor Company, said:

> Current and proposed new safety, emissions and damageability standards for the 1976, 1977 and 1978 model cars would add about $750 per car or $8 billion a year to consumer expenditures, if we could meet them all … we should have a five-year moratorium on new safety, damageability and emissions standards.[5]

Iacocca had a point. In 1975 the US was in a major recession, and had just escaped the oil-supply crisis (where Americans could only buy gas on alternate days of the week). All US automakers were in rough shape. Even if he had wanted safer cars, the business might fail if it made that investment. This doesn't let businesses off the hook, however, as they are often structured to avoid responsibility even if they are doing well.

Some businesses are excellent corporate citizens, balancing their own ambitions with the needs of the society they are part of. Yet many others are designed to maximize profits, and for the short term. This means they can justify ignoring all kinds of harm, as long as it's profitable. That includes hurting customers, employees and the world at large. Businesses often take advantage of what are called **externalities**, which means things that affect someone without them choosing it.

For centuries, and even today, businesses put waste into rivers and greenhouse gases into the air, without paying for the damage they do to our atmosphere, far greater than the collective damage done by individuals (a hundred companies are responsible for 70 percent of greenhouse gases, including ExxonMobil, Shell and Chevron).[6] This is related to the idea of the **tragedy of the commons**: if everyone abuses a shared resource, like a park or a lake, solely for personal gain, without paying back (in the form of systems like carbon taxes), eventually that resource disappears.[7] Until laws force businesses to change, few care about pollution. It's more profit for them, even if in the long term it destroys our habitat (and their business with it). GDP, a popular indicator for economic health, does not measure the quality or sustainability of our air, water, food or environment, and it can keep rising while our quality of life declines.

Colonialism, war, slavery, child labor and environmental destruction, in the past or present, usually includes organizations exploiting what is happening, and protecting that revenue source.[8] Corporations also avoid taxes, dodging their fair contribution to public systems they depend on, like roads, education and national defense. When many businesses claim they've had a great year, they're often hiding one or

more of the negative externalities they're benefiting from, or public goods they're using but don't pay for, pretending their profits aren't coming from costs others pay.

The lack of good design in terms of safety, or of many aspects of quality, can be seen as a kind of negative externality. If a laptop doesn't last or a mobile app is hard to use, why not try to externalize the costs? The way many businesses are structured often defines the primary goal as making profits for shareholders. If that's the case, why pay for employee pensions, or more safety, or better designs, when that money could be profit instead? Unless competitors are beating you in the marketplace, why not stay with the status quo?

One of the great rises of the design profession happened because of this very situation. In 1924 Alfred P. Sloan Jr., the head of General Motors, realized the car market was saturated: everyone who wanted a car had one.[9] For growth to continue, the industry needed ways to convince car owners to buy new cars, even if their old one was working fine. Today, this sounds like normal business, but at that time there was more restraint. Sloan changed all that. He put forward the idea of having a new car model every year (an idea pioneered by bicycle manufacturers).[10] He added new design enhancements, sometimes engineering improvements, but often just superficial style and exterior changes to make each new GM car more appealing than the last. This was to compete not just with Ford, but also with GM's own models from the year prior. Sloan recognized how cars could be status symbols for consumers, something people purchase to impress others rather than just to solve their practical problems. GM's creations, like the Hydra-Matic, the first automatic transmission, released in 1939, **transformed how high-tech features were named and marketed, and that influence is still felt today.**

Announcing the New Cadillac-Engineered
HYDRA·MATIC DRIVE
(Optional on All Cadillacs at Extra Cost)

ELIMINATES
CLUTCH PEDAL AND
GEARSHIFTING
●
INCREASES
ECONOMY,
SAFETY, AND
PERFORMANCE

This demanded the hiring of inventive people to create new car features and styles: designers! The number of industrial designers in the US nearly doubled in five years, from 5,500 in 1931 to 9,500 in 1936 (and this was during the Great Depression).[11] If you work in any design profession today, you owe a debt to Sloan and GM. He created the widescale business case for why better design, even if only at the level of model year styling, could be central to business strategy and profit generation. He made the most profound case for design ROI (return on investment) ever made at the time.

However, Sloan's strategy meant that thousands of perfectly good cars would be replaced much faster than necessary. It's what we now call **planned obsolescence**. Planned obsolescence is good for businesses and profits but usually creates an externality: more waste. Cars are highly recyclable, but the business model Sloan proved was attractive for many products, including plastic ones, that are not. Today, 91 percent of plastic goods are not recycled.[12]

The post-WWII economic boom in America launched consumer culture, stigmatizing the value of reusing things made to last. Lizabeth Cohen, professor of history at Harvard, explains that "The good purchaser devoted to 'more, newer and better' was the good citizen, since economic recovery after a decade and a half of depression and war depended on a dynamic mass consumption economy."[13] Today, people go into debt, work extra jobs, throw away perfectly functional goods, all to try to afford the illusion of not "falling behind." Victor Papanek once wrote, "There are professions more harmful than... design, but only a few... by creating whole species of permanent garbage to clutter up the landscape, and by choosing materials and processes that pollute the air... designers have become a dangerous breed."[14]

Of course, some obsolescence is good: it's called progress! I'm thrilled to have indoor plumbing, vaccinations and refrigeration. It's fantastic to have a better camera on your phone, or longer battery life. It's great that your software gets regular updates, automatically, with new features that make it easier to use. But progress is rarely measured against the regress it creates. Mobile phones get better each year, but we ignore that 151 million are thrown away annually, just in the US.[15] The related "cloud" data centers that run the apps we use generate 2 percent of greenhouse gases, as much as the airline industry.[16]

And those software and app upgrades often inflict more frustration, and relearning, than their designers (or their users) realize. As author and design expert Christina Wodtke explains: "[Your customers] know how it works. And one day you change it... you've basically snuck into their house and rearranged their living room furniture to a

more pleasing (to you) configuration. Without permission or warning."[17] Designers overestimate the value of their improvements, and underestimate the compounding relearning costs they create for their customers.

The time span that designers, and the organizations that hire them, tend to think about have gotten shorter, but the impacts of many of those decisions have gotten longer. To paraphrase Wendell Berry, "We do not inherit the earth from our ancestors; we borrow it from our children." If we have children, or care about the generation that will take care of us, shouldn't the balance of how we vote and make decisions be for their benefit, rather than our own? This doesn't mean businesses and profits are bad, on the contrary, they are necessary and good to motivate progress. But it does mean being honest about at whose expense those profits are coming from.

All of this amounts to a simple fact: whenever you see a design that could be better, remember: **someone has to pay for better design, and that's the organization that makes it, the customer who buys it or the government that subsidizes it.** If no one is willing to pay, or agree on ways to make improvements, it's not a design problem, it's a problem of values. Some organizations practice what's called the triple bottom line: managing for what's socially responsible for people, what's safe for the planet and what generates profit. Without this kind of broader-minded thinking, it's left to the next generations to absorb the design debt and its consequences.

10

THE POWERFUL
DECIDE

FEW THINK OF it this way, but executives are designers, too. Organizational designers. By choosing the strategy, the budget, the culture and who they hire, they have more impact on whether good design is possible than the designers themselves. Alfred Sloan would never have called himself a designer, but his choice of strategy redefined what the words *design* and *designer* meant for the world. Even the simple fact that the first designer hired at any organization is likely chosen by someone who doesn't know much about design tells you a formidable truth. What makes good or bad design happen anywhere depends on who has the most power.

An organization could hire Maya Lin, Zaha Hadid or Bjarke Ingels, three legendary architects, but if their client ignored all of their suggestions, their skills would be rendered useless. When we see great works we often give the most acclaim to the designer, but as Michael Wilford wrote, "Behind every distinctive building is an equally distinctive client." Designers and architects are often the center of attention when a work is finished, but along the way the client has the power to reject

their ideas. Sometimes designers are hired as design theater, so the powerful can say "we have talented designers," using their fame and reputation to help sell the project, even if that designer is mostly ignored.

Often there's more than one person in power, and it's their capacity to collaborate that defines what's possible. Take, for example, the town of Missoula, Montana. It's a small city with one very unusual characteristic: it has a city grid plan, but the central grid is oriented 45 degrees from the rest of the town. This makes it much easier to get lost, defeating a primary advantage of grids. What was the urban planner thinking? The answer is that there wasn't just one plan, there were two, each led by factions that couldn't agree.

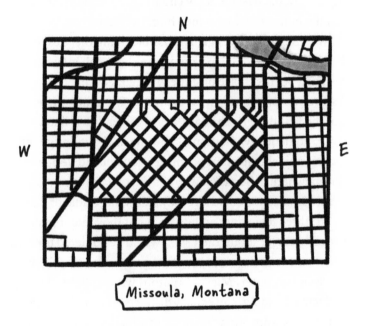

Missoula, Montana

In the 1880s, two landowners, W.M. Bickford and W.J. Stephens, owned property near an old wagon road that ran diagonally through the area. They formulated their own plan to align with it, with all streets running in a grid parallel to the wagon road (which still exists today, shown with the dashed line below). They imagined an entire town called South Missoula, with this as the core.

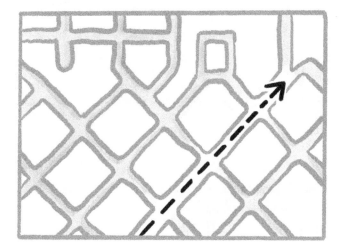

The problem was that another landowner, Judge Knowles, owned land to the north. He didn't like the plan that Bickford and Stephens proposed. He thought the angled roads were a mistake, since they ignored the original master section plan that much of the surrounding area was using. But he also didn't like the idea of there being a new town called South Missoula. He was able to get the Missoula government to agree to annex his property, and installed a true rectilinear grid plan.

At the time most of the area was undeveloped, so the official plan didn't mean that much until more roads were built and more people settled the area. There was still a chance for Bickford and Stephens to have their design become the dominant one. The pivotal factor was that an old bridge on the Clark Fork River, the Higgins Bridge, needed to be replaced. Depending on how it was positioned, it would support one grid plan over the other. Whichever road the bridge fed out to would become the primary thoroughfare.

The Higgins Bridge was named after one of Missoula's founders, C.P. Higgins, who just happened to be friends with Judge Knowles. They agreed to back the north-south alignment that Knowles had planned for, and worked together to influence citizens to take their side. Combined, they had far more influence than Bickford and Stephens, and when

it came to a vote, the north-south alignment that Knowles wanted won. The citizens of Missoula would forever pay the price.

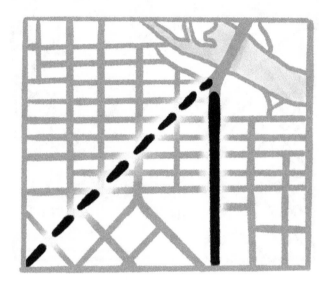

At each intersection where the two grids meet, the single street from the north-south grid has to divide into two streets, with different names. These five-legged junctions at odd angles make it unnecessarily complicated and dangerous to find your way. The worst intersection, nicknamed Malfunction Junction, had six legs, and until its recent redesign (which took eleven years to complete) it was one of the most dangerous and frustrating intersections in America.

This kind of design-by-politics is common, in cities, nations and sometimes even in products themselves. People in power often prioritize their own interests, which means good design to them is that which helps them protect their power.

The concerns of the people who will deal with the consequences, perhaps citizens, are secondary at best.

Melvin Conway, a computer programmer, expresses this idea in a law that is named after him: "Organizations ... are constrained to produce designs which are copies of the communication structures of these organizations."[1] In other words, the limitations of an organization's politics are expressed in the design of the things they produce. When one landowner, or executive, doesn't get along with another, the battle lines between them show up in the product itself, to the detriment of everyone.

This often surfaces in websites for large organizations, like government agencies or universities. Websites should focus on the most frequent things that people who visit need to do. Yet, leaders often assume that the view inside an organization

is the best one to share with the world. But that's like forcing someone who wants to watch a movie to think mostly about how it was made, the movie sets, the cameras, the lights and the producers, instead of experiencing the movie itself. Good movies work because of suspension of disbelief: they are crafted to make you forget about what went on behind the scenes, or that there were scenes, or sets, or lights, at all. Unlike the trap in chapter four, where the Segway project started with the technology first, this is a case of starting with the organization's politics first. In both cases, it's the people for whom, in theory, all of the work is being done who lose.

On a global scale, there are similar stories. At the end of World War I, the Allies worked together to decide what to do with the remains of the Ottoman Empire, which covered much of what we call the Middle East today.

The British and the French worked out a secret plan, called the Sykes–Picot Agreement, which divided up Turkish-held

Syria, Iraq, Lebanon and Palestine into areas run by the British or French government. There were three problems. First, François Georges-Picot and Mark Sykes were two mid-level diplomats acting on behalf of their European nations, who had their own agendas for the best use of these lands. Second, neither had a great a great understanding of the history of the people who lived on the lands they were redesigning. Third, the Arabs had been promised independence in return for their cooperation during the war and this pact broke that promise.

Nevertheless, they invented new nations and borders on top of hundreds of years of history and expected their new map, or nation design, to work.[2] Scott Anderson, author of *Lawrence in Arabia: War, Deceit, Imperial Folly and the Making of the Modern Middle East*, explains:

> If you look at the Middle East today, there's essentially five artificial nations that were created by Sykes–Picot, the most prominent ones being Iraq and Syria—and Jordan being another one. But anyone looking at Iraq and Syria today sees that the artificial borders that were created have now completely disintegrated … The lines crossed tribal lines. They divided up clans and sub-clans.[3]

After the act was ratified, riots and civil wars began. This shouldn't have been a surprise, but it set in motion the Middle East we know today. In response to the unrest they had created, the British and French worked to take away the power that existing groups had. They gave it instead to weak leaders they could manipulate and who posed little threat of revolting. Britain and France did nothing to help soothe the ethnic, religious or linguistic divides they had intensified.

After World War II, the US and the Soviet Union inherited the responsibility from the British and French, maintaining many of the same nation borders using many of the same methods. And according to Anderson, it wasn't until the American invasion of Iraq in 2003, and the Arab Spring, that the lid on the mess that Sykes–Picot had created by design finally came off.

Many wonder why the Middle East seems to always be in trouble. Or the borders between India and Pakistan, Israel and Palestine, or Nigeria and Cameroon. While there are many factors, one compelling lens is that people in power, often foreigners, chose the borders to be where they are. And powerful nations exert their influence on other countries for their own reasons, without understanding the history of why those efforts often fail.[4]

Americans don't have to travel far to see the power of mapmakers. Gerrymandering, where politicians in office change voting district maps to keep themselves in power, is common practice. More disturbing is the way the US government, after WWII, chose home ownership as the way to rebuild the economy and shore up the middle class for the sixteen million Americans returning from the war (including one million African Americans).[5,6] The Federal Housing Administration defined who could get loans, and their manual stated that "incompatible racial groups should not be permitted to live in the same communities."[7] They made maps of which neighborhoods could get loans: green for yes, and red for no (thus the term *redlining*).

Through these policies, poor and black neighborhoods were denied loans, as well as the right to move to neighborhoods where loans would be made available. Most Americans

assume the free market decides the fate of neighborhoods, and is why some struggle and others thrive, but that's often not true. Rey Ramsey, former chair of Habitat for Humanity, explains that despite the history, "people are lulled to sleep thinking that certain things happened by default, rather than by design."[8]

11

DESIGN IS
A VERB

IMAGINE YOU FEEL an unusual pain in your chest (perhaps caused by despair about racism and world politics) and you go to the hospital ER. As you wait in a room that's not that well designed for waiting, especially while in pain, you convince yourself you're having a heart attack. You don't have any medical training, but you've seen heart attacks appear countless times on TV and in the movies, always the most credible source for medical knowledge, and what you're experiencing matches.

Finally, you're brought to a private room to talk with a doctor. Before she can speak, you tell her, as calmly as you can manage, which isn't really calmly at all, "I'm having a heart attack! Help!" She stares at you thoughtfully for a long moment. And then, she shrugs. Without asking a single question, or checking your blood pressure, she stands up and says, "OK. I guess you're right. Let's operate right now." She reaches toward you, pulls out a rusty penknife, and gets to work.

Of course, this would be criminally negligent behavior for a doctor (she didn't even sedate you first, or have you fill out

any of their wonderful forms). Doctors know there are many possible reasons why a patient has a symptom. It would be foolish to jump immediately to a procedure, like a lung transplant, a leg amputation or surprise un-sedated open-heart surgery with a penknife. Instead, doctors are trained in a process called diagnosis, which involves asking many questions and using data from scientific tests to understand the real problem.[1] Engineers often use the 5 Whys (developed by Sakichi Toyoda, founder of Toyota Industries), asking the question "why" several times to get past symptoms and understand the cause, for similar reasons.

What does this have to do with design? All good problem solving involves diagnosis. When a plumber comes to your house to "fix a broken drain," what they do first is diagnose if the problem really is the drain, or the pipes that feed the drain, or something else. People may be good at recognizing there is a problem, but often jump quickly to precise but unlikely conclusions. (Heartburn is sometimes confused with a heart attack, mostly because many people don't know where their heart or stomach is located. Your stomach is higher than you think.[2]) Which means good doctors, plumbers and designers patiently ask questions and do research before making the same assumptions their patients, customers and clients have made.

Designers call the way they work, from diagnosing problems all the way through to solving them, their **process**. It includes how they start a project, the questions they ask, the way they explore different ideas and how they lead all those tasks toward a good solution.

In chapter three, we explored a simple process. It was remembering to ask two important questions whenever making something:

1. What are you trying to improve?
2. Who are you trying to improve it for?

But those two questions are not enough. What if assumptions were made? Or the wrong answers were chosen? Or the answers were right, but midway through the project, something changes?

This leads to a third question:

3. **How do you ensure you are successful, throughout the entire project, at improving the right thing for the right people?**

The answer comes in the shape of a loop. Since there are too many details to decide on them all simultaneously, a set of steps gets repeated. With each loop, or iteration, the quality of work improves. It's like how a novelist will write a first draft for the purpose of getting feedback, not for publication, and what they learn from each draft helps improve the next one.

Learning can take many forms. It could be watching peo-
ple use the current version of a product. It might be going to
a supermarket to watch how people pick which items to buy.
Or it may involve observing people doing their daily tasks
and then interviewing them about their biggest complaints
and pleasures. In a way, deciding what kinds of research to
do, and doing it with a minimum of bias, is a design problem,
which explains why design research is a profession unto itself.

The "create" half of the loop starts with making an inten-
tionally simple and rough attempt, in sketches or cheap
prototypes, to see what potential solutions might be like. The
goal isn't to get it right, as that's impossible. Instead the goal
is to make something that can be learned from. As Tom and
David Kelley, the founders of IDEO, believe, "If a picture is
worth a thousand words, then a good prototype is worth a
thousand pictures."[3] Without something to look at, people
have to imagine the design, and some people are better at
imagining than others. Instead, a prototype offers something
to look at, which improves the quality of the conversation,
even if it's just a conversation with yourself about what to do
next.

One surprise is how often the definition of the improvement, or problem to solve, gets refined as create-learn loops are done. Consider two problem statements: a) "My refrigerator doesn't have enough space" vs. b) "I buy more food than I can possibly eat." The same observation can be described in many ways. It's the same situation described differently, but what a difference. One suggests redesigning the entire refrigerator, the other suggests a cheaper and simpler solution. The nuance of how the problem is described transforms what kinds of solutions you're likely to consider, which means **there is a craft to defining problems that's as important as designing solutions.** This is called framing the problem—how changing your point of view, even if the object is the same, changes its meaning (see above image).

The problem is that most people like to jump directly to "solving" things. And they don't like loops. They're unfamiliar. They don't fit easily into the linear schedules they've been trained to make. Efficiency is often taught to mean working in a straight line, but the trap is that efficiency is not the same as quality. If you want quality to improve, it's going to take more time, or more thoughtful use of time.

The designers and engineers who build web services like Amazon or YouTube often work on the shortest create-learn loops, sometimes days or even hours. They prototype a small idea, learn by testing it on a small group of users, then refine it and release it to the world. Other projects, like skyscrapers or public transportation systems, which can only be built once (they hope), have to create their own smaller loops inside larger schedules, often involving a series of prototypes and tests, to give designers enough information to make good decisions that can last for decades.

Designers aren't the only professionals to work in loops. Architects, engineers, doctors, the military and other professions use them, too. Anyone who works in a job where every project has new challenges uses a loop of some kind. They've learned that loops are the most reliable way to get high-quality results. They often break their loops into more steps than just two, but the core idea is the same. Some well-known examples include:

- **Architecture:** Define, Collect, Brainstorm, Develop, Feedback, Improve
- **Military OODA:** Observe, Orient, Decide, Act
- **Medicine:** Examine, Communicate, Treat
- **UX Design:** Empathize, Define, Create, Prototype, Test
- **Total Quality Management:** Scan, Focus, Act, Feedback

The term **design thinking** has risen in popularity as a label for the set of steps that describes how good designers work.[4] It's often taught to businesspeople and young students as a way to approach and solve different kinds of problems, which is good. The challenge is that learning a set of steps is easily confused by the uninitiated as being the hard part. We could invent the term *surgeon thinking* and offer a set of steps that brain surgeons follow, but, unlike with design thinking, few would believe that knowing the steps alone gives you the abilities of a surgeon. We should not make the same mistake about design. Understanding *design thinking* isn't the same as being good at *design doing*, but it can help people on their way.

<p style="text-align: center;">12</p>

THE PASS IN YOUR POCKET

WHEN TRAVELING BY airplane there are countless designed things you use. This includes using a website to book your ticket, finding your way through the airport to your gate (which is called wayfinding) and even using your ticket to board the airplane (and let's not forget the safe and fast, if cramped, design of the aircraft itself). Most tickets, or boarding passes, look something like this:

They're odd, aren't they? The information is strangely placed, with text floating in space for no obvious reason. Some department store receipts or office forms have similar problems. A quick look at any graphic design textbook reveals there are several visual rules this pass breaks. One is that information should be prioritized: important facts should be easiest to recognize. Another is to always work with a grid. By using one, it's easier for people's brains to comprehend information. If every item lines up with an established column or row, there is less comprehension work for the eyes. This usually adds white space, or smarter use of empty areas. It's a quick way to make something less ugly and easier to read.

If you applied a simple grid, you'd get something like the image below. It's not great, but it is progress.

A talented designer named Tyler Thompson saw his ticket and went further, redesigning it as an exercise and to reduce his own frustration.[1] It's a major belief many designers have: why shouldn't everything be better? Designers are always looking, thinking and sketching: it's a habit many find hard to turn off, which is part of what makes them good designers in the first place. He also had a popular blog, and decided to share his ideas with his followers.

He came up with several variations, with the goal of improving readability and attractiveness. Here's one, for example:

His redesigns look better. The problem is that this is what's called drive-by designing. Many designers do it. I've done it. I even did it with the grid earlier in this chapter. To understand why it's problematic, let's go back to our three big questions:

1. **What are you trying to improve?**
2. **Who are you trying to improve it for?**
3. **How do you ensure you are successful?**

Thompson, without talking to customers or airline staff, decided what the problems were: they were simply what *he* thought was wrong. To be fair, he wasn't working in a professional capacity, and would have done things differently if he were. And as a good designer, he made good guesses about the problem. My point is that they were still guesses. He didn't interview customers to understand their current problems. He didn't have people use his prototypes to learn from what he observed.

Fortunately, Thompson invited other designers to give feedback and suggestions, and they responded. They raised questions and even obtained answers from airline experts. He also made the conversation visible for anyone who wanted to follow along. Good peer critique is invaluable for designers, and the online exchange that took place is a prime example.

However, drive-by design rarely succeeds at obtaining as much quality feedback as Thompson's received. In general, it's a dangerous habit for designers to presume their skills can compensate for domain ignorance. And harshly critical drive-by designs put the original designer, who likely worked for a client or corporation, at an unfair disadvantage. They often can't respond publicly to defend their work or explain

their constraints. Designers should use the golden rule when publicly criticizing other designer's work.

As it turns out, the real reason boarding passes look the way they do is their printers, something a drive-by designer could never know. Delta uses thousands of them, across dozens of gates in hundreds of airports. Most of these printers were chosen decades ago as part of the aging IT infrastructure that airlines use. Tony Capiau, an IT manager with Brussels Airlines, offered this explanation:

> The difficulty of changing the physical format of the boarding pass is that it needs to be printed on different types of printers, such as IER400s. The airline does not control which printers are being used at different airports.[2]

The IER400 is the most popular, with over fifty-five thousand in use around the world.[3] They only print at low resolution, have a fixed paper size, are thermal printers (there's no ink) and are required to put barcodes in specific places by law.

The costs of upgrading thousands of printers, supplying them with new colored ink sets, and managing the IT effects of integrating new technologies with legacy systems would cost millions. Is it worth it? Would customers pay more to get better-designed tickets? It would take some business thinking to answer those questions. To the despair of designers everywhere, sometimes better designs just aren't worth it.

Some of the choices in the "ugly" design service the needs, or use cases, of airline staff. Without studying them it'd be easy to think you'd solved a problem for the passenger, but you'd be creating new problems for others. A designer could say, "I'm just the designer. It's not my problem if the design

can't be easily built." But that's like saying, "I'm just the doctor. If my cure can't easily be given to a person, that's not my problem." Who are you really designing for if your idea can't be built? **Real design means working with real constraints**, however challenging they are. Good designers don't fear constraints. They want to solve real problems, not fantasy ones.

Drive-by design is fine as intellectual exercise, but often it's confused with, or seen as preferable to, design in the real world. Jared Spool, founder of UIE (User Interface Engineering), explains that design is always larger than the designer.[4] There are always knowledgeable people who can contribute, but they must be given direction for how to be useful. Senior product designer Diógenes Brito explains that "[good] designers are facilitators, they assist others in refining and transmitting ideas."[5] There is a design research method, called participatory design, that makes it easy to have users, customers, stakeholders, front-line workers and others contribute. Wise designers treat design like an investigation and seek out overlooked people rather than avoiding them.

The challenge soon becomes a different problem: how can a designer synthesize all the perspectives, and lead people to agree on the best decisions? The answer is facilitation, and clarifying whose role is to advise, and whose role is to decide. A film director incorporates the expertise of screenwriters, actors, producers, special effects artists and more, but everyone knows who the director is. It's true that having too many cooks is a common reason projects fail. But having too few cooks, or, more precisely, arrogant cooks who seek out too few sources of knowledge, is just as dangerous.

Next time you experience a disappointing design, ask questions about how it came to be. The design we experience

is the tip of the iceberg of business, organizational and engineering challenges the designer had to manage.

- What hidden constraints might the designer have faced?

- What technical, organizational or budget constraints impacted their choices?

- What tradeoffs did they have to make?

- Are you the user, the customer, or both?

- Who might be other users or customers they were also designing for?

- What other things did you use today that you didn't notice because they were designed so well?

13

IDEAS AND
SYSTEMS

ONE OF THE most dreaded places in the US, and in many
nations, is the Department of Motor Vehicles (DMV). The
lines are long. The rules and forms are frustrating. And the
staff seems as unhappy as the people in the unmoving lines,
absent even time estimates or placebo buttons. Why is it this
way? These offices didn't enter the universe at the moment of
the Big Bang, fully formed, with ugly carpets and glaring flu-
orescent lights. Instead they were designed by someone, or a
team of people, and evolved over years into the disappointing
experiences we know them as today. Many of those evolu-
tions might have been patches that initially solved a problem,
but over time those small solutions created new and harder
problems of their own.

It's easy to blame DMV employees, but that's misguided.
Most people who have a job want to do well. So, while our spe-
cies has many deficiencies, deliberately doing bad work and
intentionally angering people isn't one of them. More likely,
the cause is fundamental problems within the organization.
Put simply, **if an organization is bad at making decisions,
they'll be bad at making design decisions, too.**

For good ideas to make it out of the organization and into the world, three kinds of broken organizational problems need to be overcome.

1. **Design by dysfunction.** Nearly all products, services and events you experience were built by teams. The problem is, many teams don't work well together. In Patrick Lencioni's classic book, *The Five Dysfunctions of a Team*, he offers five reasons for this lack of cohesion: absence of trust, fear of conflict, lack of commitment, avoidance of accountability and inattention to results.[1] Sound familiar? No matter how talented individuals are, dysfunctional teams negate them.

2. **Design by committee.** Committees, by their nature, make consensus more important than anything else. Quality often declines if too many decisions are made by committee, as the person with the most knowledge and the person with the least have equal influence. Wise organizations realize committees are just one tool among many for decision-making. Having an empowered, specialized team to lead design decisions is a common solution.

3. **Design by regulation.** Some industries have laws restricting what can be done (and those regulations, as they are designed, may not solve the problem they were made to solve). Most organizations put more rules into place naturally as they age. But at some point these rules create so much gravity that no idea can obtain escape velocity and make it out into the world.[2] The more approvals required, the more friction there is against progress.

One way to think about this is that **an organization is a system.** A system is a set of things that work together. Thinking in terms of systems is different than thinking in terms of individual parts. If you just think about individual parts, then when one part fails you're likely to think something was wrong with just that part. But thinking about the system invites further questions: How did the other parts interact with this one to cause this outcome? And how can the system be designed differently so that each part improves, rather than diminishes, the others?

We know we can't just grab some apple seeds, sprinkle them on a cement sidewalk and expect them to grow. We'd have better odds if we made a garden, which can be thought of as a system for growing food. How much sunlight the location we choose gets, what kind of soil we buy and how frequently we water those seeds all contribute to the design of the food-growing system. Everything can be thought of as a system in one way or another, and redefining a problem in terms of a system yields insights that makes problems easier to solve.

Since organizations are systems, only changing one thing might not be enough. You could replace the leaders at your local DMV with the fantastic service designers who run Hotel Emiliano, a top-rated resort on Copacabana Beach in Rio de Janeiro, but that might not be enough to change the system (even if they magically obtained the needed domain knowledge). If the budgets, culture, employees and incentives, key parts of any organizational system, don't change, then what the system produces is also unlikely to change. Many organizations have revolving doors at senior leadership, where big names are brought in to solve major problems but don't last long, as they're not given enough power to change the system

that's in place (which might be by design, as someone else might benefit from things not changing).

One related trap is that the laws for an industry, or the policies of an organization, are often made without thinking in system terms, or without thinking through what the real outcomes of those systems will be. As Bryan Lawson explains in *How Designers Think*:

> Legislation [is] drawn up to suit those whose job it is to check rather than those whose job it is to design. The checker requires a simple test, preferably numerical, easily applied on evidence ... the checker also prefers not to have to consider more than one thing at one time. The designer, of course, requires the exact opposite of this, and so legislation often makes design more difficult.[3]

Obsessive use of metrics or KPIs, where people game the measurements for their personal benefit rather than work toward the effects the metrics were intended to create, is a similar trap. From this perspective, it's easy to see that the front-line employees at the DMV may have had excellent ideas for how to improve things, yet have no agency to make it happen. As W. Edwards Deming wrote, "A bad system will beat a good person every time."[4] Creative but ignored employees eventually give up. Organizations become self-fulfilling: the culture rejects progressives while reinforcing safety for people who fear change. Things only improve when those with sufficient power use it for progress.

You might think: "what does this have to do with design?" It's easy to forget that organizations are designed, too. When a founder starts an organization, decides its goals, structure

and budgets, they are doing organizational design, whether they know it or not. Every act of firing or hiring, or revising a policy, changes the nature and capacity of what an organization is designed to do. A quote often attributed to organizational design expert Arthur Jones says that any system or organization is **"perfectly designed to get the results that it gets."** And when an organization decides it wants different outcomes, it probably needs to redesign itself with new goals in mind.

For people with ideas, then, success depends on their ability to find allies, make pitches and navigate through rules and cultural assumptions. When you have a good or bad experience, it's easy to blame the designer in drive-by style, but the root cause is the nature of the organization that hired them.

14

THE DESIGN
REFLECTS THE TEAM

IF I ASKED you to make a smart watch for an undercover international top-secret agent, could you do it? Do you know at least seven languages, including Arabic (which is read right-to-left)? And could you make sure your design works well in all of them? Have you practiced Krav Maga, jiu-jitsu and judo, to ensure the watch won't interfere with self-defense? And do you have skydiving, deep-sea diving and hang-gliding experience to make sure it works well in the full range of realistic, and not at all based on action movies with under-cover agents in them, activities? Even the best designer would struggle, as being an undercover agent is too different from their own experiences.

Currently, about 70 percent of designers in the US are white.[1] And a majority of people in power in most corpora-tions are men.[2] I'm a white man myself, but I'm aware of the fact that half the species are not men, and most people on earth, about 70 percent, are not white.[3] To make anything good, whether it's a book or a smart watch, I have to know that most people who will use it won't be exactly like me. And

while the consequences of making bad assumptions in a book are one thing, for someone designing a sidewalk, a software product or a law, the impact on people can be devastating.

When Carol E. Reiley was working on a PhD in robotics, she built a way for a surgical robot to work with voice recognition.[4] The problem was that the voice recognition software she used, developed by Microsoft, couldn't recognize her voice. The team of people who had built it were all men: they trained their software using their own voices. In order for her to use it, she had to lower her voice, which must have been demoralizing.

The people who built the software didn't do this intentionally. They were simply working hard to build their project. Since it's easier to test things on yourself than to find volunteers, that's what they did. But the consequence was that their user, Reiley, couldn't represent her own project: her voice was literally taken away.

This situation is what Kat Holmes, author of *Mismatch: How Inclusion Shapes Design*, explains as an **exclusion habit**: a pattern of assumptions that seems to have worked in the past, but which keeps you blind to problems you're creating. As design and product leadership expert Kim Goodwin explains, even for a good-natured person, "we can't imagine types of harm we have never seen or heard about."[5] Responsible creators must accept that they will exclude people, unless they work to prevent it. Despite Nils Bohlin's seat belt and decades of car safety improvements, today women are 50 percent more likely to be injured in car crashes, as test dummies are still based on the male anatomy.[6] Sadly, standard operating procedure in many industries hides habits of exclusion.

The best way to avoid exclusion habits is simple: the more diverse your team is, the more perspectives that will be in

the room as ideas are discussed. Even before doing customer research, those perspectives will influence every decision they're allowed to genuinely contribute to. Had even just one person on that voice-recognition team been a woman, the issue would have surfaced immediately.

Sometimes designers try to be inclusive by allocating equal resources to different groups, but that can create problems, too. It's common for public places like airports and stadiums to provide equal space for men's and women's restrooms. But if you've noticed, and most women reading this certainly have, the lines for the women's restrooms are often longer than for the men's. The cause is that women on average need more time in restrooms, and for good reasons.[7] This is the difference between equality and equity. Simply dividing things evenly doesn't necessarily put everyone on the same level.

Women are more likely than men to help children or elderly parents, who enter the restroom with them. They also have to take care of menstruation needs, finding and replacing pads or tampons. Women are more likely to wash their hands (a public service) and often wear more clothes that take more time to undo and redo. There are better designs, but someone has to persuade those in power to see the benefits (for example, gender neutral bathrooms are more efficient for everyone and safer for transgender people).[8]

Earlier in this book we discussed Thor's hammer and how it has a great design for him, but one that's bad for everyone else. This is what's called **ability bias**: the assumption everyone can do what we can. We are all like Thor; we can't help it. We don't stop to think about how our height, our strength, our eyesight, our dexterity, characteristics we take for granted, might be unlike most of the people we expect to use what we make.

Race and gender are just two, but there are many ways people are different from each other that designers must consider: 10 percent of humans are left handed, 13 percent are color blind, 61 percent wear glasses (4 percent have serious visual impairment), and 15 percent have a physical disability.[9] And there are plenty more. Without considering other experiences, designers are guaranteed to exclude people.

One trap we face is that we like what's familiar. We tend to spend time with people who remind us of those we already know. We socialize online, at school and at work mostly with people like us, and we come home to people like us, too. When we visit family, guess what: unless you were adopted or have a particularly diverse family, most of your uncles, aunts and cousins are far more like you than the rest of the world. It all reinforces biases about what's familiar and what isn't. It's a self-fulfilling and limiting behavior.

Many organizations refer to "culture fit" and how, when hiring, it's important that candidates fit into the existing environment. There's danger here. It's one thing if culture fit means a desire to do good work, or having useful skills, but **it's too easy to confuse someone who is different with**

someone who won't fit in. Many differences are simply things you are not familiar with yet, but would appreciate if you gave them a chance. Every great thing in your life was once something new and unfamiliar, too.

Someone who is qualified, but different, brings fresh ways of thinking that lead to better work. They'll notice important things others don't, good and bad, that need more attention. A major factor in innovation is the sharing of an idea from one domain, or culture, into another. Reading books or traveling yields one level of intellectual diversity, but nothing equals the power of working with people who implicitly bring those perspectives into everything they contribute.

Designing for inclusion brings surprising benefits. If you ever watch videos and read the captions, you should know closed-captioning was invented to aid people with hearing disabilities. And the classic story of curb cuts, the addition of a gradual ramp between the street and a steep curb, illustrates this well. Initially put in place to allow people in wheelchairs to cross streets, it also made it easier for people on bicycles, skateboards or pushing a stroller to get around as well. It even helps folks traveling by Segway.

Henry Dreyfuss was a legend of mid-twentieth-century product design. One surprise about Dreyfuss was that his success depended on bringing diverse skills, like research, into his process. He gets acclaim for convincing the world that his vacuum cleaners, alarm clocks and telephones should be purchased because of their designs. But what's unusual about his story is that, to him, it came down to his commitment to studying people. Immature designers and researchers struggle to get along, as each sees themselves as intuitive and the other as relying on data. Dreyfuss was a synthesis. To him, both were necessary, and were helpful to each other.

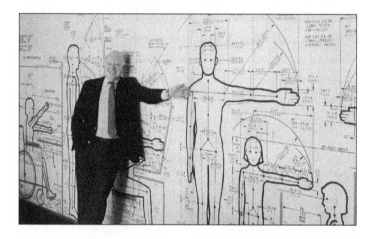

He didn't want to design for an imaginary person. He knew real people had subtle differences that mattered if he was going to make things for a wide audience. He wrote that "when the point of contact between the product and people becomes a point of friction, then the ... designer has failed."[10] He insisted on making prototypes and using them in his loop, bringing them to customers and studying how they failed.

He also insisted on learning directly what his customers experienced:

> I have washed clothes, cooked, driven a tractor, run a Diesel locomotive, spread manure, vacuumed rugs, and ridden in an armored tank. I have operated a sewing machine, a telephone switchboard, a corn picker, a lift truck, a turret lathe, and a linotype machine… I wore a hearing aid for a day and almost went deaf.

Dreyfuss was careful not to take this too far. He knew his "day in the life" research couldn't account for the compounding challenges of what it was like to do these activities every day for years. It was simply another way, beyond observing, to understand the people he was designing for. More than simply claiming to be empathetic, he forced himself and his team to actively study and learn firsthand.

Lazy designers used average measures of people, if they used data at all. But Dreyfuss knew there was no average person.[11] Instead, he did the hard work to measure the ranges of attributes, and what share of people were within each range of arm length, finger strength and more. Dreyfuss was a pioneer in using design research, or human factors. It was a major investment, but it gave his firm a strategic advantage. He published his data in a classic book that's now called *The Measure of Man and Woman: Human Factors in Design*, which originally suffered from some kinds of gender bias, but has had regular updates to capture how our bodies have changed over the decades.

Some designers resist data. They like the romance of creativity as an instinctive process. People lost in this fantasy

believe that data works against creativity, but that's more drive-by design. If they were making art, instincts alone would be fine. But for a smart watch to be successful, or a bathroom to be equitable, thoughtful use of data has to be part of the process.

15

THE WAY WE
THINK MATTERS

WHAT IS YOUR favorite kind of test? Of course, no one likes to be tested, but if you had to take one and your life depended on it, would you prefer multiple choice or a test where you had to write out answers? Most people prefer multiple choice, for a simple cognitive reason. **It's easier for our brains to recognize information than it is for us to recall it** (a concept called recognition vs. recall). When you see a list of five answers, your brain has a sample to compare against all of your memories. But with a blank, your brain has to work much harder.

Another example of this principle is the use of names. In the history of our evolution, names are a recent invention: we've probably had them for less than 30,000 of our 300,000-year species history.[1] Most of us are good at recognizing faces, as we've done that for far longer. Yet matching names to faces is harder.[2] To illustrate this, remember the last time you went to a party and talked to someone new. Minutes later you probably struggled to recall their name, and avoided addressing them to spare you from feeling embarrassed (which is quite silly: if you can recall a story they shared, that means more than remembering a string of arbitrary syllables their parents likely chose for them before they were born).

Now let's say the hosts used a social media page to list the names and photos of everyone who attended. If you could match faces to names, your odds would improve. Our brain works better with samples and designers know this. Good designers never make you remember anything that a computer can remember for you (except perhaps for passwords).

Fancy restaurants exhibit bad design in how they demand that their waiters memorize your order. It violates the rule that recognition is easier than recall, and for little benefit. You get the food you asked for either way, but if the waiter doesn't write it down there's anxiety during the wait for your dish about whether they got it right. Even if the intent is to send the style message that it's a nice restaurant, this can be done without forcing hard-working people to perform circus tricks of brainpower during dinner.

Restaurants are fascinating places to study design. They make many decisions because of style or culture rather than practical sense. Pictures of food on menus make the dishes easier to recognize, but this is considered crude. Yet, have

you ever ordered from a text menu and been unpleasantly surprised by what arrived? Menus themselves often have low contrast text with small type, forgetting that the purpose of the menu is to be read, not admired. And sometimes the food itself is functionally challenged, like overstuffed $20 hamburgers that are hard to eat without them falling apart and making a mess, breaking one of Anthony Bourdain's commandments for the perfect burger.[3]

That recognition vs. recall guideline is a useful lesson from cognitive psychology, and there are many more. Most point to one simple rule: **the more thinking a design requires of you, the worse the design.** Unless of course it's a puzzle game, or a security system intentionally made to keep you out.

Steve Krug wrote a book about good website design called *Don't Make Me Think*, and the title offers a good general rule. The better designed an email application or a washing machine is, the less time people who use it will spend thinking about how it works. Most washing machines and ovens make it clear where to put the clothes, or the food: right up front, with a big door. Oven designers generally don't hide the oven door behind secret panels requiring nine-digit codes, or make the door weigh a thousand pounds, or any of the other limitless bad choices that would create more work.

Another important rule is to **reduce mistakes, and to make mistakes safe.** A mistake, or error, is any time a person is trying to do one thing, but unintentionally does something else. Human nature makes us think this is our fault, that it's our mistake, but good designers think of it the other way: it's the design's fault. A better design would have anticipated common mistakes and made them unlikely, or at least made them easy to recover from.

When you're writing a text message, or an email, how many times do you hit either the backspace key or the undo button? It's a form of time-travel that we take for granted. Imagine how frustrating writing would be without it. You'd worry with every keystroke (which anyone who's used a classic typewriter, and a bottle of Wite-Out, remembers). Keyboards place each letter key in a fixed position, but imagine if they moved around continually, and grew and shrank in size as you tried to type. Instantly, the rate of errors would go up significantly (look up Fitts's Law for the science of why this is true). This keyboard of torture sounds ridiculous, but unless you're doing usability studies, it's easy to be unaware of the errors a design makes likely. Many products in daily life, like automobiles and guns, have features intended to reduce mistakes and increase safety, but perhaps not enough, as there are some bad decisions than can never be undone.

Inventors and entrepreneurs throughout history have failed to see how their creations enable mistakes, or could be used in ways that work against people. The Wright brothers believed airplanes would end warfare, not amplify it. Ford didn't imagine forty thousand annual traffic deaths on US

roads. The McDonald brothers didn't anticipate epidemic obesity. And, more recently, the creators of Twitter, Reddit and Facebook didn't anticipate how their creations would spread misinformation faster than the truth. People with the courage to bet their careers on their ideas are passionately optimistic. Without that uncommon emotional energy they wouldn't be capable of chasing the dreams they have. The trap is that good design requires skepticism, too. Specifically, the willingness to put ego aside, and explore how easy it would be for your creation to frustrate people or serve unsavory masters.

In an interview, the novelist William Gibson once said something like: "If you want to understand a new technology, ask yourself how it would be used in the hands of the criminal, the policeman, and the politician." If creators took even a cursory glance at the history of creations made with one intention, say, Frankenstein's monster, or the printing press, and the mixed bag of progress and regress they created, it would serve us all well. Design is never neutral,[4] or beneficial to everyone, certainly not in the way their makers presume their works will be.

16

VALUES AND TRADEOFFS

THINK OF THE last time you tried to plug something in, like a USB cable, and put it in the wrong way, even though there are only two ways it can go. It's infuriating when it happens, and it's easy to blame the person who made these "Norman plugs." The truth is that, at least in the case of the USB, what seems to be a flaw was a deliberate design tradeoff. A tradeoff means that two desired goals are in conflict, and the designer must make a decision that intentionally prioritizes one over the other, instead of ruining them both.

Before USB existed, connecting a keyboard, printer or game controller to your computer was an exercise in frustration. There were seven different oddly designed adapters, some requiring physically opening the computer to install, and when you bought new equipment you never knew if you had the right one (or if it would work). Ajay Bhatt and his team at Intel wanted to replace them all with a single, simpler standard (now known as USB). But the task of convincing many competing corporations to change to one standard, that none of them could control, was going to difficult.

Bhatt's team did have a design that was foolproof to use: it could be connected in either direction. Problem was, it would double the wiring and electronics required, doubling the cost. Higher costs would have made it harder to convince corporations to change, which put the project at risk (remember: someone has to pay). They chose to go with the simpler, cheaper, one-sided design. They made the tradeoff of prioritizing the larger breakthrough (one simple standard) over the specific details of what that standard would be. They made the design rectangular, instead of circular (like some adapters of the era), to ensure at least 50/50 odds of a successful first try.

With this focus, they were able to convince Microsoft, Compaq, NEC, IBM and Apple to use it, and it was a great success, one of the great triumphs of simplification through standardization. We might complain now at the annoyance of flipping USB adaptors, but in comparison to the daily annoyances people experienced a generation ago, it was a design victory, paving the way for the USB-C standard, which works in either direction.

Tradeoffs are central to understanding design. It's inevitable in any pursuit that some goals you want to achieve are in tension with others. You might start a project desiring high quality and low cost, but eventually you'll have to decide to choose one over the other (for example, your neural-Matrix interface may turn out to require a unique, expensive part). At the beginning of projects, when both optimism and ignorance are in abundance, it's easy not to notice tradeoffs that will need to be made. Sometimes you can find an elegant solution that dances its way around them, but often the best design comes from clarity about the compromises you will make if you have to.

One common tradeoff in design is about simplicity. Simpler designs prevent mistakes and are easier to learn. But the tradeoff is that "simple" means it can't do as many things as a complex alternative could. Some try to cheat this tradeoff, but they usually end up with the equivalent of the previously discussed Swiss Army knife: it does many things, but it doesn't do any of them well (except for being portable). Or the designer bets on people's willingness to change default settings, which most people never do.[1]

Consider a basic kitchen appliance, like a toaster. If a toaster has only one button that says TOAST, the number of possible mistakes a person can make is low. Much lower than a design with a touchscreen LCD panel, thirty toasting levels, a robotic tray that auto-lowers the bread, a hundred options for sports team logos and national flags you can have burned onto the toast, a Butter'O'Matic auto-buttering system, antilock bread brakes (you don't want that finished toast flying through the air when it's done), Bluetooth notification so you get an SMS when your toast is ready and a compartment to fry an egg synchronized to be ready when your custom toast is finished. Now, I bet at least one of those features sounded interesting to you, which exposes a challenge between good design and what people value.

Let's study two toasters. First, the BergHOFF Seren ($86). It has a simple design, with a slide-out tray that makes toast getting stuck impossible, and a wide carriage that can fit bagels or English muffins. It's simple, and focused on solving the problem of "toast my mostly flat pieces of bread-like objects without fuss." The style is clean, with rounded edges, offering a classy and timeless message (would it look right in a kitchen in 1980, today and in 2040?) about its purpose.

Next is the Nostalgia BSET300BLUE Retro Series 3-in-1 ($65 on Amazon).

This is not just a toaster. It offers two additional toast-complementary devices, a coffee maker and a griddle, making it, as the name says, "a breakfast station." It seems aimed at solving the problem of "I need to be able to make an entire meal with a limited amount of space and cost."

Which toaster is better? You already know that this is a trick question. We need to first do some work to figure out

what we're trying to improve (making better toast or providing a "complete breakfast solution") and who we're improving it for (someone in a big home with a large kitchen that has an oven and a coffee maker, or someone in a small apartment with little space and few electrical outlets). But let's put that aside momentarily.

When people are about to buy something, they think about value, and primarily the economic kind. For the $20, $60 or $100 you can spend on a toaster, how much value will you get? And **the easiest way for our brains to think about value is in quantity.** You'd never pay $10 for two apples if you could get four of them, of the same quality, for $10 (yes, these are expensive apples). The problem is that design is hard to measure in terms of quantity. You wouldn't judge a car for how many tires it has (unless you were going off-roading to prepare for the zombie apocalypse) or judge wine by the size of its bottle (unless you crash your car in a ditch and the zombie apocalypse begins).

To measure design quality requires more than just looking: you have to use the thing for its purpose. We try on clothes and we test-drive cars, but often we don't get to try before we decide. Even a test-drive isn't great: you only get to drive the car for a few miles around the dealership. You can't try your daily commute, or packing for a family vacation, or taking your route from the market to your home.

As a result of our bias toward quantity, we make mistakes about evaluating how good something will be for us. When you compare our two toasters based on features, you get a comparison chart like this:

FEATURE	BERGHOFF SEREN	NOSTALGIA BSET300BLUE
Make toast	X	X
Make coffee		X
Fry eggs		X
Fry bacon		X
Make pizza		X
Make French toast		X
Make tea		X
Dispense zombie antidote tablets		

Based on features, the Seren is a loser. It doesn't do much. But the trap is that features are not the same as a problem being solved for you. For example, a toaster could have an air horn that plays the opening of Beethoven's 5th Symphony at a frequency only dogs can hear when the toast is ready, another feature, but the existence of that feature has little bearing on solving another problem (unless I want my toast stolen by our

canine friend Nibbles). However, by framing the decision to be about features, which advertisements often do, it benefits the corporation that made it more than the customer. Most designers will tell you that **simplicity means value.** It means that the designer has thought carefully about your needs, and has elegantly satisfied them so you don't need to do much. But our quantity-oriented brains, and our desire to get more value, tend to make us think complexity means value. So we buy the toaster or the phone or the software that impresses us with how many things it claims it can do. Victor Papanek wrote about the difference between design for sale and design for use. Is the goal to make something that's appealing before it's purchased, or something that satisfies real needs?

There's nothing wrong with a product that has more features, provided those features are useful and, ideally, don't burden people. Adding anti-lock brakes to a car, for example, makes it safer without adding complexity. It just works. However, most features of most products have a user interface, buttons, screens and switches that the user has to operate. And the more buttons and screens there are, the more complex the experience will be. Which means the more likely the user is to make mistakes, and the harder it will be to recover from them.

If you study the user interface for the BSET300BLUE, you'll notice problems that won't show on a feature list. First, there are strange instructions above the red on/off switch. As general rule of design, **the more instructions something has, the worse its design** (complexity!). It's cheaper to add instructions later than to design something well. And, of course, just because instructions are provided doesn't mean they were designed well and actually help.

The instructions say:

If setting baking time within 5 minutes choose 6 first, then set the time you want.

This is troubling. All of the options for toasting come before the five-minute mark, so to toast bread you have to turn the knob to 6, and then backward to set your toast level. This makes you take an extra step every time. If design is how it works, this works in a way that creates more work, not less. It's a small sacrifice of time, but no one would choose to do this.

More importantly, according to reviews, the grill, the toaster and the coffee maker have quality problems. You can't control the temperature of the grill, it's either on or off. The grill pan isn't level, so eggs run while they're cooking.[2] And it takes a long time to get hot, so you have to plan ahead. Just

because something can do more things doesn't mean it can do any of them well. Of course, for some people the complexity and quality issues are worth it. If they don't have space or the money for three appliances, the tradeoff between nothing or a device that does a mediocre job is an easy one.

But sometimes thoughtful complexity is the right choice. Take a fighter-airplane cockpit, for example. It demands significant work from the operator's brain. But it might be the best way to allow a pilot to do their job. Here's what the cockpit for an F-22 Raptor fighter jet looks like.

Consider that the same fighter plane could also have a much simpler interface. You can play the game Tom Clancy's HAWX on an Xbox, and fly the same plane. The difference is that the Xbox controller has a fraction of the complexity of the real thing.

The designer of the actual cockpit was willing to trade away simplicity in favor of useful complexity, useful for the person

it's designed for. They were OK with pilots needing hundreds of hours of training before they'd ever be responsible for not dropping bombs by accident. Whereas the designers of the game traded away complexity in favor of simplicity, to make it fun and easy to learn. These tradeoffs are good and necessary. The fighter pilot would hate to fly a mission with the Xbox controller, and the game player would hate to try to play a fun action game with a real fighter aircraft cockpit.

Perhaps the most important tradeoffs and values are the ones that get lost in discussions about products. People who buy things are called consumers, which implies that **their primary value is what they consume, rather than what they learn, what they hope for or what they wish to contribute to society.** It's not hard to realize you can make toast in an oven, or in a pan, in just a couple of minutes, about as long as a toaster takes. There's nothing magical about a toaster: it uses the same nichrome heating elements kitchen ovens do, just shrunk down and turned on their side. But no organization that exists to sell toasters will ever tell you that.

Many products and services are sold on the basis of saving us time, or their low cost, but those savings often have hidden

expenses (what externality makes it possible?) or lower our expectations for what we can learn to do for ourselves. Often learning basic skills, like how to properly use a kitchen knife or make a simple, healthy meal from scratch, eliminates the need for countless gadgets, apps and services. Sometimes the best solution to a problem doesn't require designing something new or buying anything at all.

17

DESIGN IS
HOW IT FLOWS

WHEN YOU WATCH your favorite movie, maybe *The Hunger Games* or a documentary about Margaret Vivienne Calvert, who designed the UK highway sign system, you're really watching a series of still images. Each image, or frame, moves fast enough (twenty-four per second) that our brains perceive them as real-life motion. When Thomas Edison invented the Kinetoscope, an early film system, in 1891, it was well known that a rate of just sixteen frames per second was required for our brains to experience the sensation of real-life movement. And the higher the frame rate, the better the illusion of motion.

However, film engineering has tradeoffs, too: those higher frame rates would use more film and cost more to make. The standard of twenty-four frames has more to do with the realities of film production than with how our brains work (which explains why some filmmakers, like Peter Jackson, are interested in how digital production makes higher frame rates possible).[1] Either way, the experience of watching a good film, where you're not thinking about still images moving, depends

on thoughtful use of technology to design an experience that feels natural.

One word for this is *flow*: how one moment moves into the next without annoyances or disruptions. Flow is usually pleasurable. It means we can focus on what we're doing, rather than on how it's done. Good design usually means people experience flow while they're using the designed thing, even to the point that they're not consciously aware that they're using a designed thing at all.

When you're riding a train across a suspension bridge, high above a raging white-capped river, you're not thinking about how nice it is that there is another twenty feet of bridge ahead of you so you won't fall to your death, nor that inside the engineering car a diesel engine injects fuel droplets that explode instantly inside metal cylinders thirty times a second, generating the power that moves you along. Instead you're thinking about how lovely it will be to make it home in time for dinner.

Flow, much like a bridge without a gaping hole in it, does not happen by accident. It takes work to think through how to design something so that flow can take place. Much like how our brains actually watch films, a designer has to carefully use technology to link together different bits of information to make them have flow and feel like one unified experience.

To do this, designers often think in terms of tasks. Not tasks that they have to do, but the tasks, or use cases or scenarios, of the people they are designing for. By thinking in terms of tasks, a designer can think about how to order those tasks, or connect them, to make doing the tasks and the transitions between them feel effortless. This view of design applies to anything, software, your kitchen or even getting around town.

Take, for example, the design of an airport. When people arrive, they have several different tasks they need to complete to get on their flight:

- Learn information about their flight. (What gate? Is it delayed?)
- Find their way to the right security line.
- Make their way to their boarding gate.
- Get something to eat.
- Obtain their boarding pass from their airline.
- Go to the bathroom.
- Check their bags with their airline.

All of these tasks are important: how can one be prioritized above another? How can the airport be organized so that passengers are able to complete each task at the right time? And find their way from one place to another? It's not easy. If you've tried to do one of these tasks in an airport and felt confused, you're in the majority. Between the number of different airlines, terminals, security protocols, languages and throngs of busy and stressed-out people, finding flow through an airport is a challenge.

Designing for flow starts with thinking about first things first. In that list of tasks, what's the one that everyone has to do first? Obtain a boarding pass! But not so fast. For the person taking a trip, the airport is not where their trip starts: it starts in their home or office (where they might download a digital pass to their phone). If we're thinking people first, we need to think about their experience, not just where "our design" begins. As Paul Mijksenaar, one of the designers of Amsterdam's Schiphol Airport wayfinding system, known for its excellent design, explains:

We view the whole travel process as stressful. It starts off with packing your bags, making sure your tickets are at hand, worrying about traffic jams on the way to the airport.[2]

Most people who make things think about the best cases. They assume that their users will be in good moods, on good days, in good lives. That's rarely the case, but it's convenient! There's less design work if it's just a series of best cases. Mijksenaar is realistic about who he is designing for and what problem he needs to solve. He realizes that they enter his world already in a bad kind of flow, and he needs to make sure that his design choices help them toward the happier kind.

Mijksenaar used four principles[3] to guide his team's design decisions toward creating flow, which I've slightly modified here. They are universal, and apply to anything people use. Many designers use lists like these, called heuristics, to help guide their work:

- **Continuity:** information that's offered for one task is repeated, at timely intervals, until the task is completed or destination reached.

- **Discoverability:** the right information should be the easiest to notice at the right time, and different items should never compete for attention.

- **Consistency:** the same icons, colors and terms are always used. A "restaurant" should not become a "snack bar." Terms, colors and other items should only need to be learned once.

- **Clarity:** the meaning of every message must be clear to as many people as possible, even if they speak a different language.

This thinking applies from the moment people arrive at the airport. At Schiphol, each garage has its own theme, identified by distinctive images that anyone in any language can understand, and can likely recognize, even after a long trip. It's a technique often used now in amusement parks and shopping malls. The color yellow is always used for information about the most needed things, like parking or gates. The consistency of this gently reinforces for passengers that when they most urgently need to get somewhere travel related, it's probably information with black text on a yellow background.

When a passenger finds their way inside, there are more kinds of information, but each is colored and sized differently, based on what's most likely to be important in that specific location. Items in blue are discretionary things like restaurants, bars or casinos (beware of slot machines!). A black background is for serious services, like toilets, changing money or getting first aid. Items in green are always

emergency exits. These exits are rarely needed, so they should never be the most or second-most prominent, but they are important, so nothing else is ever the color green.

This all seems smart and straightforward, but you have to remember that airports are omnidirectional. People have to be able to find their way from any one point in the airport to any other. Just like we experience information overload on computers, there is so much information that you might need in an airport that it can be easy to get lost. To help reduce the chances of this happening, and to help travelers stay in flow, Mijksenaar made another powerful choice:

> All the information signs are positioned so they're facing the traveler… while advertising is positioned at the sides, so you see it as you pass by. But it doesn't obstruct the view of the information signs. It's another principle of psychology about separating information.[4]

On the web, this clear separation for advertising is uncommon, since if what you are using is free, the business model doesn't allow for it.

Separating information for flow, and deciding what to show and what to leave out at any given time, applies to everything. Productivity software and even mobile apps usually have menus, or screens filled with different options. They can either be designed with flow in mind, and a clear idea of what commands you'll need at any moment, or they can be designed generically, without thought about flow at all. And that's usually when you notice the menus and the screens: when they fail you. In most cases, when you notice how something is designed, the designer hasn't done a good job.

As Mijksenaar offers, "We don't want anyone to think about our wayfinding or even notice that they're being guided. We just want them to arrive."[5] Henry Dreyfuss's dictum about removing "points of friction" applies almost everywhere.

But sometimes there are advantages to making people notice something. At the same airport, maintenance worker Jos Van Bedoff realized how expensive it was to clean the men's rooms. The major reason was embarrassingly simple: bad aim. He'd learned in the Dutch army that placing something small inside the urinals, like a simple red dot, gave men something to aim at. He suggested the idea to manager Aad Kieboom, using a fly as the target. And it worked, reducing spillage by 80 percent, significantly reducing cleaning costs.[6]

The rationale is simple. While going to the bathroom there isn't anything to do. There's nothing to read, and nothing to watch (except your phone, contributing to bad stream targeting). By design, every section of urinals in most bathrooms expects men to just stare at a blank wall. But by being given a

target, there is something to do. According to urinal designer
Klaus Reichardt:

> Guys are simple-minded and love to play with their urine
> stream, so you put something in the toilet bowl and they'll
> aim at that ... It could be anything. I've seen a golf flag, a bee,
> a little tree. It just happens that at Schiphol it's a fly.[7]

With their attention focused somewhere, their behavior
changed. And by choosing something people don't like, like
an insect, it feels acceptable to aim for it. (Apparently urinals
in Britain did this too, a hundred years ago, but used bees
instead.[8]) It's a clever use of design to influence behavior
in a natural way. Mike Friedberger at American Standard,
which makes the fly-engraved urinals used at JFK Terminal 4,
says, "If they had put a pretty butterfly or ladybug there, men
might not aim directly at it. On the other hand, if you used an

ugly-looking spider or a cockroach, people might be afraid of it and not even stand there. A fly seems to be a compromise: something that is universally disliked, but that doesn't elicit fear and make people not want to stand there."[9]

18

DESIGN FOR CONFLICT

AT THE TORTUREUM, the museum of torture in Croatia, there is a special utensil with a most unusual design. It's called the Heretic's Fork. It has four tines, but they are placed at opposite ends, two facing in each direction. It was designed to "motivate" people who committed heresy against the church during the Spanish Inquisition. The side of the fork had one word, *abiuro*, which basically means "I recant." The victim, or user, would first have their hands tied behind their back. Then the fork would be tied around their neck and placed under their chin, with the other end resting against their chest.

Just for fun, tilt your head back. Far enough that you're looking at the ceiling. Imagine now that you're wearing a Heretic's Fork. Since your hands are tied, you can't move very easily. How long do you think you could stay in this position? You'd have to stay just like you are to prevent the forks from digging into your skin. Slowly, your muscles would tire, your neck would ache, and your body's natural design would work against you. The muscles in your head and neck aren't capable of staying in one position for very long.

Would you say this fork is designed well? Instead of designing for flow, this is designing for the exact opposite experience, pain, where all the person can think about is their suffering. This seems like a terrible kind of design.

But let's return to our three questions. And imagine it's 1480 and you're King Ferdinand II, the leader of the Spanish Inquisition, a monarch who wanted to convert everyone to Catholicism.

1. **What are you trying to improve?** I want to convert everyone to my religion and I want to make them suffer until they give in.

2. **Who are you trying to improve it for?** Everyone, including my enemies and people I don't like!

3. **How do you ensure you're successful?** We will test it on hundreds of unwilling people, and through the create-learn loop of iterative design we will improve and learn!

Suddenly these questions feel different. Ethics are important, but clumsy to discuss within the language of design. With the answers to the three questions above, we'd have to say that the Heretic's Fork is well designed for its purpose. But

can we call it good design? The word *good* implies ethically good, and most people know torture is ethically wrong. Perhaps it'd be best to say this a well-designed object made for evil purposes, as a designer could do a good job creating a reprehensible thing. More often, things help some people and hurt others. A fence, or a gun, is good or bad depending on which side of it you're on and for what reason. Sometimes a design helps and hurts the same person, like a double milkshake that gives pleasure but at a hidden cost. When you start to look, there are many designed things in our lives that have ethical complexity.

Consider the casino slot machine. These devices seem innocent, as they don't put sharp objects under people's chins, but they are cunningly designed. Their pretense is that there is predictable logic for wins and losses, like at blackjack. The reality is the algorithms are engineered to maximize attention in harmful ways. Wins are provided at a pace that maximizes

the addictiveness of playing. Kathy Sierra, product design expert and author of *Badass: Making Users Awesome*, explains it this way:

> It was one of B.F. Skinner's most important discoveries that... behavior reinforced intermittently, as opposed to consistently, is the most difficult to extinguish. In other words, intermittent rewards beat predictable rewards. It's the basis of most animal training, but applies to humans as well... which is why slot machines are so appealing, and one needn't be addicted to feel it.[1]

The way Snapchat, Facebook or Instagram notifies us of likes or comments uses similar methods. Social media notifications are designed to offer intermittent treats to us, instead of to rats like the ones Skinner used. Catherine Price, author of *How to Break Up with Your Phone*, says that apps are designed to mimic the addictive qualities of slot machines, with triggers such as notifications, likes, and messages releasing a rush of pleasurable dopamine. In a discussion of Price's book, the writer Rachel Saslow warns, "Our brains have learned to associate checking our phones with the possibility of getting a reward."[2] It's the uncertainty of when a new email or like notification will come that drives the addiction. We check our phones an average of fifty-seven times a day, fueled by the hope that dopamine awaits.[3]

The designers of social media and slot machines would say they are profiting from providing something people like, and what's wrong with that? Many slot machine fans will admit they don't expect to make money, there's just nothing else they'd rather do. But where is the ethical line? An addiction is defined by compulsive behavior despite harmful

consequences. What right do people have to know how the systems they use function? If they were aware of how they really work, and how harm can come with pleasure, they might feel differently.

Unlike the wayfinding goals for the Schiphol Airport, casinos have the opposite intent. They are crafted like mazes. In Natasha Dow Schüll's book *Addiction by Design: Machine Gambling in Las Vegas*, she quotes casino design consultant Bill Friedman: "A maze layout rivets visitors' attention on the equipment immediately ahead. The slot faces at the ends of the short, narrow aisles are thrust right at them. The convoluted, dead-end pathways force walkers to focus on the machines to avoid bumping into them. If a visitor has a propensity to gamble, the maze layout will evoke it."[4] Casinos also typically have no clocks and no natural light, suspending your sense of time.

This intent behind labyrinthine casinos is similar to the thinking Temple Grandin pioneered for slaughterhouses, adopting curved chutes instead of straight lines, using architecture to influence behavior to keep livestock, or people, moving in the "right" direction.[5] And if casinos and slaughterhouses seem too far removed, consider supermarkets. There's a reason why staples like milk and eggs are in the back, ensuring you'll travel up at least one aisle, past dozens of more profitable products for sale (it may be easier for the store to maintain, as well). The placement of every row, the nature of every special or sale and the position of each product on every shelf are thoughtful decisions trying to influence your behavior in ways you wouldn't want if you were aware of them.[6]

It's no surprise that businesses go to inventive lengths for profits. But it's disturbing when they work against the interest

of their own customers. Corporations now think of their customer's time as a kind of externality. The CEO of Netflix, Reed Hastings, recently said, "You get a ... movie you're dying to watch, and you end up staying up late at night, so we actually compete with sleep ... and we're winning!"[7] Sleep is actually a national health issue, and technology design is part of the problem. In 1910 the average American slept nine hours. In 2013, despite having more leisure time than a hundred years ago, the average was 6.8 hours.[8] Similarly, it's lifestyle diseases like heart disease, obesity and type 2 diabetes, conditions often caused by habits more than genetics, that have exploded in frequency in the last decades. This is in part the result of convenience culture, and a food industry that profits from selling customers more food than is healthy, and designing food to maximize its addictive qualities.[9]

Design for conflict is when a situation is created that generates tension between people. When fighting over the

armrest in the middle seat on an airplane, it's easy to blame the person who bumps your elbow, or slides their foot into your space. But remember, someone designed those seats. What problem were they trying to solve? Fitting more people on airplanes makes airlines more profitable, but could they have achieved this without making you angry at your seatmate?[10] In a talk for Ignite Seattle, interior designer Bonnie Toland explained that sometimes the way things are made "sets us up to blame each other, instead of the design [or the designer]."[11] We blame our neighbor, or our airplane seatmate, but forget the people who created the problematic situation. This leads to our fourth and final question:

4. Who might be hurt by your work, now or in the future?

Even the best design impacts someone, perhaps just by excluding them. Or it could be your competition, or someone whose job might be eliminated, or a person who has to do more work or learn something new (and who doesn't want to). Is there a way to improve the world just as much but with lower negative impact? Doctors have the Hippocratic Oath, which includes the statement "First, do no harm." But designers, engineers, executives and politicians have no similar creed.[12]

When Waze and other navigation apps began suggesting previously uncommon routes to their users, they never expected they'd disrupt quiet family neighborhoods.[13] Facebook, created to connect people, has had the effect of polarizing and dividing people (yet another problem founder Zuckerberg has apologized for).[14] Airbnb causes rents to rise.[15] Uses of artificial intelligence in business and medicine,

presumed to be neutral, have gender and racial bias (if the training data is biased, so is the "intelligence").[16] Designers regularly create conflicts and problems they never intended.

You can find deliberate design for conflict in many urban areas, in what is called hostile design, or hostile architecture. Much like how a moat around a castle is designed to keep outsiders away, some cities prevent people from using urban spaces. Take, for example, this set of stairs on a street in Marseille, France. They added bolts to the stone to prevent people from sitting or sleeping there. Often, it's the young, the homeless and the poor that are impacted the most, since they depend on public spaces more than most citizens.

Yet these choices affect everyone in subtle ways, as hostile architecture often adds inconveniences. In the same way that inclusive design, like curb cuts on sidewalks, often has secondary benefits for all, hostile architecture often has secondary downsides. For example, that Marseille stairway is no

longer a place someone can stand while waiting for a friend, or sit to read a book. Putting a slant on a bench or adding metal armrests to prevent people from sleeping makes the bench less comfortable for anyone, and for any purpose.[17] The saddest part is that these designs are shallow and do nothing to help reduce homelessness. They only make the experience of being homeless harder.

In the African country of Mali, courthouses are designed with low ceilings. Called togunas, these community spaces prevent conflict, since citizens who have quarrels are unlikely to physically confront each other if they can't stand.[18] And talking sticks, a native American tradition among tribes in the Pacific Northwest, allows each person the power to speak without being interrupted (something your workplace meetings might benefit from). Design for peace, or harmony, is something we can achieve, too.

19

SOLUTIONS CREATE
PROBLEMS

ALTHOUGH EVERY DOCTOR will tell you the importance of
sleep, nowhere is this reflected in the experience of *staying*
at a hospital. It's shockingly hard to rest as a patient in even
our most advanced medical centers. In Ancient Greece they
had asclepeions, temples of healing (likely our first hospitals)
that were designed with rest in mind. A common treatment
was called "temple sleep," where the patient would lie com-
fortably in the center of the temple, and the priest or priestess
would guide them gently into sleep, encouraging them, likely
through incense and chants, to dream. (Egyptian temples,
which may predate the Greeks', practiced this, too.)

They hoped the gods would appear in their dreams to
cure them, but if that didn't happen a priest would prescribe
a more earthly remedy, often something as simple as taking
a bath or going to a gymnasium (which, given the long his-
tory of quack medicine, from bloodletting to lobotomies, was
good advice).

Somehow this basic wisdom regarding sleep for the sick
has been lost. It didn't happen all at once. Each new invention,

like electronic IV machines, ID scanners, intercoms, respirators, telephones or heart-rate monitors, became common in hospitals one at a time. Slowly, like a thousand small cuts, each new designed thing, successful in solving its own little problem, created a new one. Each warning beep and blinking light, designed independently of the others, eventually worked against the larger purpose of healing people. It's a problem for nurses and staff, but it hurts the patients, too. The problem is so pervasive that it has its own name in the medical community: **alarm fatigue**.

Emily S. Rueb, reporting for the *New York Times*, explains: "A single patient might trigger hundreds [of alarms] each day, challenging caregivers to figure out which machine is beeping, and what is wrong with the patient, if anything."[1] Many alarms are false, contributing to deaths when real ones are ignored. (From 2005 to 2008 there were over five hundred such reported deaths, says Rueb.) And even when these devices properly alert staff, all too often the last thing dying patients hear is the cacophony of multiple alarms.

Doctors have known for a long time, at least as far back as the Greeks and the Egyptians, that noise creates stress.[2] Florence Nightingale, a pioneer not only in medicine but also in the graphic presentation of medical data, called needless noise "the most cruel absence of care."[3] But inventions are often Trojan horses, bringing unforeseen problems along for the ride.

Many of the themes from earlier chapters also surface here. The exclusion habit is reflected in designers likely not having spent much time in hospital beds or working as nurses during a busy shift. Even though none of these makers had the goal of "irritate patients and nurses," that was the result. They didn't learn enough about who they were designing for

to identify these non-goals, things they should have planned to avoid. Whatever their create–learn loop was, it didn't include early testing of their ideas in the real world. And patients themselves are captive customers: if they find one hospital's choice of equipment unpleasant, they can't easily pick up and move to a different one.

There are also organizational systems at work that limit what designers can do. The IEC 60601-1-8, a standard for sounds that get used in any item of medical equipment, mandates the use of just six sounds—sounds that were never tested and in some cases combine to create what's called the devil's interval (F-sharp and C), which is so unpleasant it was banned in churches during the medieval era, when it was believed that devil lived in this combination of tones.[4]

It was a committee, and not a team of trained designers, who decided on IEC 60601-1-8. Frank Block, one of the members of the committee, apologized for the results: "We did the best we could . . . but the sounds were basically terrible."[5] And given the risks of lawsuits, some manufacturers feared being liable if they were blamed for their alarms not being loud enough. In other words, their fear about their business expenses (avoiding rightful liability is a kind of externality) contributed to design choices that put the health of their users at risk.

From one perspective, what goes on in a hospital room is designs colliding, or competing for attention. Daily life is filled with design collisions. Communication tools like Facebook Messenger, WhatsApp, email and SMS provide similar functionality, but don't really talk to each other. Proprietary digital file formats are hard to convert into more commonly used ones. Gasoline-powered leaf blowers, motorcycles and

loud mobile phone talkers on public transit make it hard to hear anything else. Different regions on the planet have their own electric outlet plug designs. Hot dogs come in packages of twelve, but buns in eight. In a way, designers are at war with each other. Even here in the US, a look at the strip mall, a staple of our people-made landscape, reveals dozens of designs in competition, each yelling their message at the same time.

Of course, we don't want to live in a world where everything is tightly regulated by one authority, standardizing everything. That approach has its problems, too. But designers should see how, when they design in isolation, the results are worse. Ignoring how a creation fits in with everything else that's already here often defeats its own purpose, and makes it harder for creations that follow.

Finnish architect Eliel Saarinen had simple advice for avoiding these problems. "Always design a thing by considering it in its next larger context—a chair in a room, a room in

a house, a house in … a city plan."[6] When designers follow this notion, their aim is always better. It's an antidote to the poisons of design ego and to getting lost in the pleasure of building something.

Whenever we visit historic towns, or nations with strong design cultures, like Japan or the Netherlands, there is a coherency to how things fit together. Everyone has agreed to simple rules, sometimes implicit, other times enforced, to prevent designs from colliding. And because of those agreements, everyone benefits from the surroundings being more attractive, less stressful and more humane. People want to spend more time in these places, and business continue to thrive without having to resort to screaming for attention.

Even without the challenges of designers competing with each other, a tougher problem may arise when a design competes against itself: that the **success of a design leads to its own failure.**

When the US built its interstate highway system in the 1950s, the automobile was an amazing innovation. Until then,

suburbs were limited to rail lines in cities like London or New York, but the car allowed people to commute to almost anywhere. As the system of roads and highways grew, the utility of owning cars increased. Cities declined in population and home ownership rose (due to federal loans and access to cheaper real estate), all because of cars.

James Howard Kunstler, author of *The Geography of Nowhere*, describes the ascendancy of automobiles as unique: "There was nothing like it before in history: a machine that promised liberation from the daily bondage of place. And in a free country like the United States, with the unrestricted right to travel, a vast geographical territory to spread out into, and a national tradition of picking up and moving whenever life became intolerable, the automobile came as a blessing."[7] Similar praise has been lauded on the revolutionary impact of the internet and mobile phones.

But just thirty years later, cars were so successful that the urban infrastructure they were based on began to break down, and today it's falling apart. Traffic is so pervasive in cities that travel times have doubled or tripled, even over short distances. The natural response, to add more roads to congested areas, **doesn't reduce traffic**. It simply encourages more people to drive, but with the same poor experience. This counterintuitive fact is called *induced demand*, a lesson learned only by thinking about cities not as parts, but as systems.[8] Systems are influenced by feedback loops, which means design changes can have effects that are hard to predict. People hate traffic when that are in it, but forget they are part of the system too: they are "the traffic" to all the people in cars behind them.

This is troubling news for designers. In simple terms, it was the very success of the car's design that led to its failure.

And given the massive infrastructure we have, with billions in maintenance needed to renovate aging bridges and highways, reducing urban traffic must depend on using cars less, not more. Any city road only has so much space, and since many cars are low occupancy, they're inefficient compared to trains or buses. Transportation expert Jarrett Walker explains: "In cities, urban space is the ultimate currency."[9] Buses, bicycles and trains are now most likely the best design choice for urban transportation (and perhaps they always were, given their lower impact on the environment). And it will take a generation of different design choices to shift how cities work for the better. It's been done in Lyon, Birmingham and even in London. And we shouldn't forget what can be learned from bicycle-centric havens like Copenhagen and Amsterdam.

All designs, even high-tech ones, run the same risk of success creating problems. The widespread adoption of mobile phones is one of the great mass technological changes in history, but that success means that distracted driving (and all forms of multitasking), binge-watching and social media addiction are here to stay, too. That is, unless we find new designs, like Bohlin's seat belt (but designed more inclusively),

that respond to weaknesses in what we've made and compensate for them. We rarely think about it this way, but most of design is redesign: applying what we know now to design choices made before us.

We've collectively chosen to make the internet depend on advertising. This choice makes everything seem free, but we've learned that when something is free online it means *we* are the product, with our data being sold to advertisers. The effect this has on our perception of reality is hard to comprehend. What shows up at the top of our searches on the free media provided by Google, Facebook or YouTube is decided by algorithms designed by businesses with short-term profits in mind. They know it's the most emotionally triggering content that gets the most attention, which is better for advertising sales. These businesses are motivated to share such videos and articles first, regardless of their accuracy or quality. Much like the slot machine, we presume there is a fair algorithm, but we know now that's not true.

Product manager James Mayes has proposed a **product ethics test** for people who design and build these services. In the test he asks: would you be willing to stand on a stage in front of your users and explain how your product guides their behavior and makes suggestions? So far no one has volunteered to take it.[10] Food, drugs, electronics and even broadcast media are regulated for safety in most countries, but few do the same for our providers of online information.

All change, even if as successful as the car, or the web, creates waves of positive and negative effects. Designers and entrepreneurs deserve their fair share of the credit for moving us forward, but should be just as accountable for how they've sent us backward.

The challenge we face is this: how far into the future are we designing for? Are we willing to think through design collisions? Unintended consequences? Can we balance our individual desires with contributing to society and the longevity of the human experiment on planet earth?

These are questions not just for designers, but for everyone. Because the powerful decide, and someone has to pay, it's what the trio of society, government and business agrees on that defines our future.[11] None of them can do it alone. Which means, even for the brightest designers we have, it will be their ability to lead, persuade and collaborate with those in power, and their fellow citizens, that will guide to us making a better world.

20

HOW TO SEE
A DESIGN CHECKLIST
FOR YOUR WORLD

TO HELP YOU bring the ideas from this book with you, here's a simple checklist. It can be used for anything, anytime, anywhere.

The four questions:

1. What are you trying to improve?

2. Who are you trying to improve it for?

3. How do you ensure you are successful?

4. Who might be hurt by your work, now or in the future?

What to ask of things you see around you:

- What were they trying to improve?

- Who were they trying to improve it for?

- How successful were they?

- What hidden constraints could explain its weaknesses?

- Who were the powerful people who made these decisions?

- Who paid for it?

- Did people come first, or a technology, or an organization?

- What message is the style sending to you? Who is included or excluded from participating?

- What systems is this design a part of?

- Where in the natural world, or in another culture, might there be a better solution for this problem?

- Does this design create flow or conflict?

- What new problems does this design create if it's successful?

- What are you going to do about all of this? (If in doubt, start a conversation.)

TAKE ACTION
IMPROVE THE DESIGN
OF THE WORLD

IT'S A BIG WORLD and this is a small book. Can you take a moment to help more people see the importance of good design?

Here's what you can do:

- Share this book with a leader or influential person you know.

- Write a review on Amazon.com to encourage those who find it to read it.

- Help me teach this book's lessons by recommending me as a keynote speaker at events. See **scottberkun.com/ speaking**.

- Visit **designmtw.com** to find resources beyond this book and information on how to volunteer and get involved, and to discover other design leaders and their work.

- Join my mailing list at **scottberkun.com/d-follow** to learn about new projects, design mission updates and more.

Thanks—your help matters more than you know.

RECOMMENDATIONS

How to learn more about design

A great book on the history of design is *Hello World* by design critic Alice Rawsthorn, which eloquently explores the wide design world, from graphic to industrial to digital. George Nelson's *How to See* and Sarah Williams Goldhagen's *Welcome to Your World* will delight you by helping you notice and question the designed things you experience every day. The podcast *99% Invisible* is a great source for good storytelling about design that's accessible to everyone.

If you're interested in user experience (UX) design, the classic introduction to usability and cognitive psychology (how our brains interact with the world) is *The Design of Everyday Things* by Don Norman (get the second edition). If you want an easy way to explore a simple kind of design research, pick up *Don't Make Me Think* by Steve Krug. To grow your understanding of aesthetics and style, start with *The Non-Designer's Design Book* by Robin Williams. A great primer on urban planning is *Urbanized*, part of Gary Hustwit's trilogy of design documentaries.

Look for local design or UX design meetups near you (meetup.com/topics/ux-design) as there is no better way to learn than from other designers.

How to pursue design as a career

The world needs more and better designers. Like any profession, it takes experience and mentorship to develop design skills, but there are a wide range of vocational and four-year programs to move you toward becoming a professional, depending on what kind of design you choose to practice. Start with "How to Transition into a Design Career," an essay by Ram Castillo at the American Institute of Graphic Arts (aiga.org/career-transition-design-discipline-advice). And, of course, many design careers begin by simply taking a pencil and paper and redesigning something you think could have been designed better... and then showing it to an expert and learning from their feedback. If you enjoy the experience, keep going. If not, be a design supporter and help more people appreciate the work that good designers do.

Design for good

Technopoly by Neil Postman is a must-read for exposing our blind spots about the faith we put in technology to solve our problems. It pairs well with the more recent and internet-savvy *Technically Wrong* by Sara Wachter-Boettcher, which documents countless ways our modern designs in social media and high tech (intentionally or not) build in many kinds of bias, manipulation and deception. Not to be missed is *The Responsible Object*, a compendium of essays, including

writing by Andrea Bandoni, that explores the history of social movements for using design for the greater good. Go to **designmtw.com** for more.

Ranked bibliography

Here's a ranked list ordered by the number of notes I made while doing research (which is a better design than the standard alphabetical listing). This is not a perfect measure: one profound note might have influenced me more than a dozen small ones, and shorter books, or books I only read partially, won't have as many opportunities for notes as longer ones. That said, it gives a sense of which works had the most influence and value during this project.

(112) *Hello World: Where Design Meets Life*, Alice Rawsthorn

(102) *Welcome to Your World: How the Built Environment Shapes Our Lives*, Sarah Williams Goldhagen

(89) *Systemantics*, John Gall

(77) *Designing for People*, Henry Dreyfuss

(76) *How Designers Think*, Bryan Lawson

(48) *Design for the Real World: Human Ecology and Social Change*, Victor Papanek

(45) *Form, Function & Design*, Paul Jacques Grillo

(36) *The Responsible Object: A History of Design Ideology for the Future*, Marjanne Van Helvert (ed.)

(36) *Are We Human? Notes on an Archaeology of Design*, Beatriz Colomina and Mark Wigley

(34) *The Design of Everyday Things*, Don Norman

(34) *Technically Wrong: Sexist Apps, Biased Algorithms, and Other Threats of Toxic Tech*, Sara Wachter-Boettcher

(33) *Toothpicks and Logos: Design in Everyday Life*, John Heskett

(33) *The Death and Life of Great American Cities*, Jane Jacobs

(31) *How to Make Sense of Any Mess: Information Architecture for Everybody*, Abby Covert

(30) *Irresistible: The Rise of Addictive Technology and the Business of Keeping Us Hooked*, Adam Alter

(29) *Tragic Design: The Impact of Bad Product Design and How to Fix It*, Cynthia Savard Saucier and Jonathan Shariat

(29) *CAD Monkeys, Dinosaur Babies, and T-Shaped People: Inside the World of Design Thinking and How It Can Spark Creativity and Innovation*, Warren Berger

(24) *Mismatch: How Inclusion Shapes Design*, Kat Holmes

(22) *How Buildings Learn: What Happens after They're Built*, Stewart Brand

(21) *Do Good Design: How Design Can Change Our World*, David Berman

(19) *101 Things I Learned in Architecture School*, Matthew Frederick

(19) *Design Is Storytelling*, Ellen Lupton

(18) *How to See: Visual Adventures in a World God Never Made*, George Nelson

(18) *Dark Matter and Trojan Horses: A Strategic Design Vocabulary*, Dan Hill

(17) *Ways of Seeing*, John Berger

(15) *Why Design? Activities and Projects from the National Building Museum*, Anna Slafer and Kevin Cahill

(15) *Understanding Comics: The Invisible Art*, Scott McCloud

(14) *Invisible Women: Data Bias in a World Designed for Men*, Caroline Criado Perez

(12) *101 Things I Learned in Urban Design School*, Matthew Frederick and Vikas Mehta

(11) *The Evolution of Useful Things: How Everyday Artifacts— from Forks and Pins to Paper Clips and Zippers—Came to Be as They Are*, Henry Petroski

(10) *The Geography of Nowhere: The Rise and Decline of America's Man-Made Landscape*, James Kunstler

(10) *Are Your Lights On? How to Figure out What the Problem Really Is*, Donald C. Gause and Gerald M. Weinberg

(8) *Design Methods*, John Chris Jones

(7) *Don't Make Me Think: A Common Sense Approach to Web Usability*, Steve Krug

(7) *The Ten Books on Architecture*, Marcus Vitruvius Pollio

(6) *What Is a Designer: Things, Places, Messages*, Norman Potter

(6) *The Vignelli Canon*, Massimo Vignelli

(6) MAN transFORMS: *An International Exhibition on Aspects of Design for the Opening of the Smithsonian Institution's National Museum of Design, Cooper-Hewitt Museum*, Hans Hollein

(5) *Change by Design: How Design Thinking Transforms Organizations and Inspires Innovation*, Tim Brown

(5) *Design and Truth*, Robert Grudin

(5) *Design Thinking*, Peter Rowe

(5) *A Life's Design: The Life and Work of Industrial Designer Charles Harrison*, Charles Harrison

(5) *Design for Hackers: Reverse Engineering Beauty*, David Kadavy

(5) *100 Things Every Designer Needs to Know about People*, Susan Weinschenk

(5) *The Architecture of Happiness*, Alain de Botton

(4) *Architecture without Architects: A Short Introduction to Non-Pedigreed Architecture*, Bernard Rudofsky

(4) *How Things Don't Work*, James Hennessey and Victor Papanek

(4) *Astrophysics for People in a Hurry*, Neil deGrasse Tyson

(4) *The Designer's Eye: Problem-Solving in Architectural Design*, Brent C. Brolin

(3) *Design Games: Playing for Keeps with Personal and Environmental Design Decisions*, by Henry Sanoff

(3) *Total Design: Integrated Methods for Successful Product Engineering*, Stuart Pugh

CANONICAL TEXTS I read in younger days that influenced my thinking on design include *The Art of Human-Computer Interface Design* edited by Brenda Laurel, *The Elements of Friendly Software Design* by Paul Heckel, *The Great Bridge* by David McCullough, *Empires of Light* by Jill Jonnes, *Information Anxiety* by Richard Saul Wurman, *Technopoly* by Neil Postman, *Understanding Comics* by Scott McCloud and *About Face* by Alan Cooper and colleagues.

Movies and other media studied during research

- *Eames: The Architect and the Painter* (2011), produced by Jason Cohn and Bill Jersey
- *Tucker: The Man and His Dream* (1988), directed by Francis Ford Coppola
- *Owned: A Tale of Two Americas* (2018), directed by Giorgio Angelini
- *Helvetica* (2007), directed by Gary Hustwit
- *Objectified* (2009), directed by Gary Hustwit
- *Urbanized* (2011), directed by Gary Hustwit
- *Rams* (2018), directed by Gary Hustwit
- *Abstract: The Art of Design* (2017), Netflix series
- *The Genius of Design* (2010), BBC series

- *99% Invisible*, created by Roman Mars (podcast)
- *What Is Wrong with UX?*, created by Laura Klein and Kate Rutter (podcast)
- *High Resolution*, created by Bobby Ghoshal and Jared Erondu (podcast)
- *Louis Sullivan: The Struggle for American Architecture* (2010), directed by Mark Richard Smith
- *Zaha Hadid: Who Dares Wins* (2013), directed by Lindsey Hanlon and Roger Parsons
- *The Founder* (2016), directed by John Lee Hancock
- *Design DNA* (2010), Castlewood Productions
- *Design Is One: Lella & Massimo Vignelli* (2012), directed by Kathy Brew and Roberto Guerra
- *Three Walls* (2011), directed by Zaheed Mawani
- *The Pruitt-Igoe Myth* (2011), directed by Chad Freidrichs
- *Be Like an Ant* (2012), directed by Mike Plante
- *The Toilet: An Unspoken History* (2012), directed by Nick Watts
- "Leading Design Out of Obscurity" (2018), talk by Khoi Vinh, Leading Design Conference
- "Design Thinking Is Bullshit" (2017), talk by Natasha Jen, Adobe 99U Conference

NOTES

CHAPTER 1: EVERYTHING HAS A DESIGN

1. Elaine Peltier et al., "Notre-Dame Came Far Closer to Collapsing Than People Knew," *New York Times*, July 16, 2019, https://www.nytimes.com/interactive/2019/07/16/world/europe/notre-dame.html.

CHAPTER 2: BUILDING VS. DESIGNING

1. You can read Jared Spool's discussion of the four stages of incompetence at https://articles.uie.com/four_stages_competence.
2. Douglas Martin, *Book Design: A Practical Introduction* (Van Nostrand Reinhold, 1990).
3. Justin Elliot, "Congress Is about to Ban the Government from Offering Free Online Tax Filing. Thank TurboTax," *ProPublica*, April 9, 2019, https://www.propublica.org/article/congress-is-about-to-ban-the-government-from-offering-free-online-tax-filing-thank-turbotax.

CHAPTER 3: WHAT IS GOOD?

1. Mindy Weisberger, "Why Are Human Babies So Helpless?" *Live Science*, May 2, 2016, https://www.livescience.com/54605-why-are-babies-helpless.html.
2. David Anderson et al., "5 Everyday Hand Gestures That Can Get You in Serious Trouble outside the US," *Business Insider*, January 5, 2019, https://www.businessinsider.com/hand-gestures-offensive-different-countries-2018-6.

CHAPTER 4: PEOPLE COME FIRST

1. All of the quotes in this paragraph are taken from John Heilemann, "Reinventing the Wheel," *Time*, December 2, 2001, http://content.time.com/time/business/article/0,8599,186660,00.html.
2. The car and bicycle figures both come from Worldometer, https://www.worldometers.info.
3. Jacuzzi, "Jacuzzi History," https://www.jacuzzi.co.uk/jacuzzi-world/history. The story of the home treatments is told by Ken Jacuzzi himself in the video on this page.
4. Sub-Zero, "Our Heritage," https://www.subzero-wolf.com/company/our-heritage.

CHAPTER 5: EVERYONE DESIGNS SOMETHING

1. Bureau of Labor Statistics, "Occupational Outlook Handbook: Aerospace Engineers," https://www.bls.gov/ooh/architecture-and-engineering/aerospace-engineers.htm.
2. Victor Papanek, *Design for the Real World: Human Ecology and Social Change* (Academy, 2005).
3. The Earth Institute, "Humans Shaped Stone Axes 1.8 Million Years Ago, Study Says," September 1, 2011, https://www.earth.columbia.edu/articles/view/2839.

CHAPTER 6: THE STREET YOU LIVE ON

1. Laurence Aurbach, "A Brief History of Grid Plans, Ancient to Renaissance," originally published on Ped Shed, November 30, 2006; archived copy available at https://web.archive.org/web/20170424194044/http://pedshed.net/?p=12.
2. Paul Knight, "Choose the Grid? Absolutely," The Great American Grid, February 26, 2012, http://www.thegreatamericangrid.com/archives/1656.
3. Patrick Rodgers, "SF Icons: Lombard Street," San Francisco Travel Association, July 16, 2019, https://www.sftravel.com/article/sf-icons-lombard-street.
4. Oliver Smith, "The World's Steepest Streets," *The Telegraph*, December 23, 2016, https://www.telegraph.co.uk/travel/destinations/oceania/new-zealand/articles/baldwin-street-steepest-roads-in-the-world.
5. Hundertwasser, "Friedensreich Hundertwasser (1928–2000)," https://hundertwasser.com/jart/prj3/hundertwasser/main.jart.
6. Paul Jacques Grillo, *Form, Function & Design* (Dover, 1975).

7. Gwen Pearson, "How Flies Fly," *Wired*, January 22, 2015, https://www.wired.com/2015/01/flies-fly.

8. Tom McKeag, "How One Engineer's Birdwatching Made Japan's Bullet Train Better," *Green Biz*, October 9, 2012, https://www.greenbiz.com/blog/2012/10/19/how-one-engineers-birdwatching-made-japans-bullet-train-better.

9. Beatriz Colomina and Mark Wigley, *Are We Human? Notes on an Archeology of Design* (Lars Müller, 2017).

CHAPTER 7: STYLE IS A MESSAGE

1. University of York, "Handaxes of 1.7 Million Years Ago: 'Trust Rather Than Lust' behind Fine Details," press release, November 21, 2012, available at https://www.sciencedaily.com/releases/2012/11/121121075756.htm.

2. Gemma Tarlach, "Prehistoric Use of Ochre Can Tell Us about the Evolution of Humans' Cognitive Development," *Discover Magazine*, April 2018, http://discovermagazine.com/2018/apr/pigment-of-our-imagination.

3. Sarah Griffiths, "Your Brain Really Is Faster Than You Think," *Daily Mail*, January 20, 2014, https://www.dailymail.co.uk/sciencetech/article-2542583/scientists-record-fastest-time-human-image-takes-just-13-milliseconds.html.

4. Charles Spence, "On the Psychological Impact of Food Colour," *Flavour* 4:21 (2015), https://doi.org/10.1186/s13411-015-0031-3.

5. You can watch the "Cerulean Top" scene from *The Devil Wears Prada* on YouTube: https://www.youtube.com/watch?v=vL-KQijoI81.

6. Mukti Jain Campion, "How the World Loved the Swastika—until Hitler Stole It," *BBC News*, October 23, 2014, https://www.bbc.com/news/magazine-29644591.

7. This and the following quote are taken from Alice Rawsthorn, "Skull and Crossbones as Branding Tool," *New York Times*, May 1, 2011, https://www.nytimes.com/2011/05/02/arts/02iht-design02.html.

CHAPTER 8: DESIGN IS HOW IT WORKS

1. Christopher Mele, "Pushing That Crosswalk Button May Make You Feel Better, But...," *New York Times*, October 27, 2016, https://www.nytimes.com/2016/10/28/us/placebo-buttons-elevators-crosswalks.html.

2. Kendra Cherry, "Locus of Control and Your Life," *Very Well Mind*, September 13, 2019, https://www.verywellmind.com/what-is-locus-of-control-2795434; see also Yasemin Saplakoglu, "Why Does Time Fly When You're Having Fun?" *Live Science*, March 2, 2019, https://www.livescience.com/64901-time-fly-having-fun.html.

3. Quoted in Alex Stone, "Why Waiting in Line Is Torture," *New York Times*, August 19, 2012, https://www.nytimes.com/2012/08/19/opinion/sunday/why-waiting-in-line-is-torture.html.

4. Ana Swanson, "What You Hate about Waiting Isn't the Wait at All," *Washington Post*, November 27, 2015, https://www.washingtonpost.com/news/wonk/wp/2015/11/27/what-you-hate-about-waiting-in-line-isnt-the-wait-at-all.

5. Ferris Jabr, "How Sugar and Fat Trick the Brain into Wanting More Food," *Scientific American*, January 1, 2016, https://www.scientificamerican.com/article/how-sugar-and-fat-trick-the-brain-into-wanting-more-food.

6. Federation of American Societies for Experimental Biology, "Highly Processed Foods Dominate U.S. Grocery Purchases," press release, March 29, 2015, available at https://www.sciencedaily.com/releases/2015/03/150329141017.htm.

7. Stephanie Soechtig, director, *Fed Up*, 2014 film, http://fedupmovie.com.

8. Quoted in Rob Walker, "The Guts of a New Machine," *New York Times*, November 30, 2003, https://www.nytimes.com/2003/11/30/magazine/the-guts-of-a-new-machine.html.

9. Environmental Protection Agency, "Global Greenhouse Gas Emissions Data," https://www.epa.gov/ghgemissions/global-greenhouse-gas-emissions-data.

CHAPTER 9: SOMEONE HAS TO PAY

1. Sean O'Grady, "The Man Who Saved a Million Lives: Nils Bohlin," *The Independent*, August 19, 2009, https://www.independent.co.uk/life-style/motoring/features/the-man-who-saved-a-million-lives-nils-bohlin-inventor-of-the-seatbelt-1773844.html.

2. Elizabeth Mendes, "The Study That Helped Spur the U.S. Stop-Smoking Movement," American Cancer Society, January 9, 2014, https://www.cancer.org/latest-news/the-study-that-helped-spur-the-us-stop-smoking-movement.html.

3. National Highway Safety Administration, "Seat Belts Save Lives," https://www.nhtsa.gov/seat-belts/seat-belts-save-lives.

4. For more on the creation of design mythology, see my book *The Myths of Innovation* (O'Reilly Media, 2010).

5. Quoted in Walter Rugaber, "Industry Resists Car-Safety Costs," *New York Times*, April 4, 2006, https://www.nytimes.com/1975/04/06/archives/industry-resists-carsafety-costs-companies-feel-consumers-will.html.

6. Tess Riley, "Just 100 Companies Responsible for 71% of Global Emissions, Study Says," *The Guardian*, July 10, 2017, https://www.theguardian.com/sustainable-business/2017/jul/10/100-fossil-fuel-companies-investors-responsible-71-global-emissions-cdp-study-climate-change.

7. Jim Chappelow, "Tragedy of the Commons," *Investopedia*, May 10, 2019, https://www.investopedia.com/terms/t/tragedy-of-the-commons.asp.

8. Joel Bakan, *The Corporation: The Pathological Pursuit of Profit and Power* (Penguin Canada, 2004).

9. Melissa Block, host, "GM's Role in American Life," *All Things Considered*, NPR radio program; transcript posted April 2, 2009; available at https://www.npr.org/templates/story/story.php?storyId=102670076.

10. Automotive News, "Annual Model Change Was the Result of Affluence, Technology, Advertising," September 14, 2008, https://www.autonews.com/article/20080914/OEM02/309149950/annual-model-change-was-the-result-of-affluence-technology-advertising.

11. Beno Benhabib, *Manufacturing: Design, Production, Automation, and Integration* (CRC Press, 2003).

12. Laura Parker, "A Whopping 91% of Plastic Isn't Recycled," *National Geographic*, December 20, 2018, https://www.nationalgeographic.com/news/2017/07/plastic-produced-recycling-waste-ocean-trash-debris-environment.

13. Quoted in PBS, "The Rise of American Consumerism," https://www.pbs.org/wgbh/americanexperience/features/tupperware-consumer.

14. Papanek, *Design for the Real World*.

15. Nathan Proctor, "Americans Toss 151 Million Phones a Year," WBUR, December 11, 2018, https://www.wbur.org/cognoscenti/2018/12/11/right-to-repair-nathan-proctor.

16. Michael Rohwer, "The Data Center Emissions Challenge—It's Not Just the Big Guys," GreenBiz, August 31, 2017, https://www.greenbiz.com/article/data-center-emissions-challenge-its-not-just-big-guys.

17. Christina Wodtke, "Users Don't Hate Change, They Hate You," *Medium*, September 16, 2013, https://medium.com/@cwodtke/users-dont-hate-change-they-hate-you-461772fbcac7.

CHAPTER 10: THE POWERFUL DECIDE

1. A broader discussion of Conway's Law can be found on Wikipedia at https://en.wikipedia.org/wiki/Conway%27s_law.

2. The Sykes–Picot map and a discussion of the agreement can be found on Wikipedia at https://en.m.wikipedia.org/wiki/Sykes%E2%80%93Picot_Agreement#/media/File%3APeace-conference-memoranda-respecting-syria-arabia-palestine5.jpg.

3. Scott Anderson on Robert Siegel, host, *All Things Considered*, NPR radio program; transcript posted May 13, 2016; available at https://www.npr.org/2016/05/13/477974553/lawrence-in-arabia-author-examines-lasting-impact-of-sykes-picot-agreement.
4. Stephen Kinzer, *Overthrow: America's Century of Regime Change from Hawaii to Iraq* (Times Books, 2007).
5. US Department of Veterans Affairs, "America's Wars," pdf fact sheet, https://www.va.gov/opa/publications/factsheets/fs_americas_wars.pdf.
6. Henry Louis Gates Jr., "What Was Black America's Double War?" PBS, https://www.pbs.org/wnet/african-americans-many-rivers-to-cross/history/what-was-black-americas-double-war.
7. Terry Gross, "A 'Forgotten History' of How the U.S. Government Segregated America," NPR, May 3, 2017, https://www.npr.org/2017/05/03/526655831/a-forgotten-history-of-how-the-u-s-government-segregated-america.
8. Rey Ramsey in Giorgio Angelini, director, *Owned: A Tale of Two Americas*, 2018 film, http://www.ownedfilm.com.

CHAPTER 11: DESIGN IS A VERB

1. Erin P. Balogh et al., "The Diagnostic Process," from *Improving Diagnosis in Health Care* (National Academic Press, 2015); chapter available at https://www.nap.edu/read/21794/chapter/4#32.
2. Harold M. Schmeck Jr., "When Chest Pains Have Nothing to Do with a Heart Attack," *New York Times*, January 19, 1989, https://www.nytimes.com/1989/01/19/us/health-symptoms-diagnosis-when-chest-pains-have-nothing-with-heart-attack.html.
3. Catherine Fredman, "The IDEO Difference," *Hemispheres*, August 2002; pdf available at https://www.ideo.com/news/the-ideo-difference.
4. Christina Wodtke, "Five Habits of Design Thinking," *Medium*, July 2, 2019, https://medium.com/@cwodtke/five-habits-of-design-thinking-45bb61b30393.

CHAPTER 12: THE PASS IN YOUR POCKET

1. A summary of Tyler Thompson's entire boarding pass experiment can be found at http://passfail.squarespace.com.
2. Tony Capiau, "While I Was Redesigning a Boarding Pass, Paper Got Old," *UX Planet*, August 2, 2016, https://uxplanet.org/while-i-was-redesigning-a-boarding-pass-paper-got-old-eda92055dd29.
3. Airport Suppliers, "IER 400, Multi-functional Check-in Printer," https://www.airport-suppliers.com/product/ier-400-multi-functional-check-in-printer.

4. Jared Spool's entire 2017 presentation at UCI Donald Bren School of Information & Computer Sciences, called "Design Is a Team Sport," can be viewed on YouTube at https://www.youtube.com/watch?v=sjTK9z5-tl4.

5. Diógenes Brito's entire presentation at Leading Design 2018, called "Leading without Authority: Leadership as a Designer or a Dancer," can be seen on Vimeo at https://vimeo.com/297910836.

CHAPTER 13: IDEAS AND SYSTEMS

1. Patrick Lencioni, *The Five Dysfunctions of a Team: A Leadership Fable* (Jossey-Bass, 2002).

2. Dan Hill, *Dark Matter and Trojan Horses: A Strategic Design Vocabulary* (Strelka Press, 2014).

3. Bryan Lawson, *How Designers Think: The Design Process Demystified* (Architectural Press, 2005).

4. Quoted in John Hunter, "A Bad System Will Beat a Good Person Every Time," The W. Edwards Deming Institute, blog post, February 26, 2015, https://blog.deming.org/2015/02/a-bad-system-will-beat-a-good-person-every-time.

CHAPTER 14: THE DESIGN REFLECTS THE TEAM

1. Meg Miller, "Survey: Design Is 73% White," *Fast Company*, January 31, 2017, https://www.fastcompany.com/3067659/survey-design-is-73-white.

2. Zameena Mejia, "Just 24 Female CEOs Lead the Companies on the 2018 Fortune 500—Fewer Than Last Year," CNBC, May 21, 2018, https://www.cnbc.com/2018/05/21/2018s-fortune-500-companies-have-just-24-female-ceos.html.

3. 100 People Foundation, "A World Portrait," https://www.100people.org/statistics_100stats.php.

4. Carol Reiley, "When Bias in Product Design Means Life or Death," *TechCrunch*, November 16, 2016, https://techcrunch.com/2016/11/16/when-bias-in-product-design-means-life-or-death.

5. Kim Goodwin, "Organization as a Designed System," live lecture at the From Business to Buttons conference, Stockholm, Sweden, May 2019.

6. Sarah Holder, "A Clue to the Reason for Women's Pervasive Car-Safety Problem," CityLab, July 18, 2019, https://www.citylab.com/transportation/2019/07/car-accident-injury-safety-women-dummy-seatbelt/594049.

7. Lisel O'Dwyer, "Why Queues for Women's Toilets Are Longer Than Men's," *The Conversation*, August 23, 2018, https://theconversation.com/why-queues-for-womens-toilets-are-longer-than-mens-99763.

8. Luc Bovens and Alexandru Marcoci, "To Those Who Oppose Gender-Neutral Toilets: They're Better for Everybody," *The Guardian*, December 1, 2017, https://www.theguardian.com/commentisfree/2017/dec/01/gender-neutral-toilets-better-everybody-rage-latrine-trans-disabled.

9. World Health Organization, "Global Data on Visual Impairments 2010," pdf fact sheet, https://www.who.int/blindness/GLOBALDATAFINALfor web.pdf; see also the World Bank, "Disability Inclusion," https://www.worldbank.org/en/topic/disability.

10. This and the following quote are both taken from the preface to Henry Dreyfuss's *Designing for People* (Allworth, 2012).

11. Todd Rose, *The End of Average: How We Succeed in a World That Values Sameness* (HarperOne, 2016).

CHAPTER 15: THE WAY WE THINK MATTERS

1. Robert Krulwich, "Who's the First Person in History Whose Name We Know?" *National Geographic*, August 19, 2015, https://www.nationalgeographic.com/science/phenomena/2015/08/19/whos-the-first-person-in-history-whose-name-we-know.

2. Adam Hadhazy, "Why Do We Remember Faces but Not Names?" *Science Friday*, June 10, 2013, https://www.sciencefriday.com/articles/why-do-we-remember-faces-but-not-names.

3. You can find Bourdain's commandments for a good burger on *Thrillist* at https://www.thrillist.com/eat/nation/anthony-bourdain-parts-unknown-tips-how-to-make-burgers.

4. Colleen Tighe offers an excellent illustrated example of how design is never neutral. You can find it on the *Baffler* at https://thebaffler.com/odds-and-ends/design-is-not-neutral-tighe.

CHAPTER 16: VALUES AND TRADEOFFS

1. Charles Arthur, "Why the Default Settings on Your Device Should Be Right the First Time," *The Guardian*, December 1, 2013, https://www.theguardian.com/technology/2013/dec/01/default-settings-change-phones-computers.

2. Samantha Gordon, "We Tried the Internet's Favorite 3-in-1 Breakfast Maker—Was It Worth the Hype?" *Reviewed*, June 1, 2017, https://www.reviewed.com/cooking/news/i-tried-this-3-in-1-breakfast-appliance-so-you-dont-have-to.

CHAPTER 17: DESIGN IS HOW IT FLOWS

1. Eric Escobar, "Hacking Film: Why 24 Frames Per Second?" *Film Independent*, April 16, 2018, https://www.filmindependent.org/blog/hacking-film-24-frames-per-second.

2. Paul Mijksenaar in Sarah Domogala, director, *Dutch Profiles: Paul Mijksenaar*, 2012 film, https://vimeo.com/50915913.

3. More on Paul Mijksenaar's philosophy, including what he calls "the Four Cs" (Continuity, Conspicuousness, Consistency and Clarity), can be found at his firm's website: https://www.mijksenaar.com/design-philosophy.

4. Mijksenaar, "Design Philosophy," https://www.mijksenaar.com/design-philosophy.

5. Ibid.

6. Blake Evans-Pritchard, "Aiming to Reduce Cleaning Costs," *Words That Work* 1 (Winter 2013), https://worksthatwork.com/1/urinal-fly.

7. Ibid.

8. Robert Krulwich, "There's a Fly in My Urinal," NPR, December 19, 2009, https://www.npr.org/templates/story/story.php?storyId=121310977.

9. Quoted in Evans-Pritchard, "Aiming."

CHAPTER 18: DESIGN FOR CONFLICT

1. Kathy Sierra, "Is Twitter Too Good?" *Passionate*, blog post, March 2007, https://headrush.typepad.com/creating_passionate_users/2007/03/is_twitter_too_.html.

2. Rachel Saslow, "How to Stop Looking at Your Phone," *Vox*, October 23, 2019, https://www.vox.com/the-highlight/2019/10/15/20903620/phone-addiction-stop-looking-at-your-smartphone.

3. Abrar Al-Heeti, "Americans Are Checking Their Phones Now More Than Ever, Report Says," CNET, November 12, 2018, https://www.cnet.com/news/americans-are-checking-their-phones-now-more-than-ever-report-says.

4. Quoted in Natasha Dow Schüll, *Addiction by Design: Machine Gambling in Las Vegas* (Princeton University Press, 2012).

5. Two resources that illustrate the relationship between architecture and behavior are Karin Jaschke and Silke Ötsch's edited volume *Stripping Las Vegas: A Contextual Review of Casino Resort Architecture* (University of Weimar Press, 2003) and Ryan Bell's "Temple Grandin, Killing Them Softly at Slaughterhouses for 30 Years," *National Geographic*, August 19, 2015, https://www.nationalgeographic.com/people-and-culture/food/the-plate/2015/08/19/temple-grandin-killing-them-softly-at-slaughterhouses-for-30-years.

6. Emma Kumer, "The Real Reason Your Grocery Store Milk Gets Put in the Back," *Taste of Home*, https://www.tasteofhome.com/article/the-real-reason-your-grocery-store-milk-gets-put-in-the-back.

7. Quoted in Rina Raphael, "Netflix CEO Reed Hastings: Sleep Is Our Competition," *Fast Company*, November 6, 2017, https://www.fastcompany.com/40491939/netflix-ceo-reed-hastings-sleep-is-our-competition.

8. Neil Howe, "America the Sleep-Deprived," *Forbes*, August 18, 2017, https://www.forbes.com/sites/neilhowe/2017/08/18/america-the-sleep-deprived.

9. Walter C. Willett et al., "Prevention of Chronic Disease by Means of Diet and Lifestyle Changes," from *Disease Control Priorities in Developing Countries* 2, D.T. Jamison et al., eds. (Oxford University Press, 2006).

10. Tim Wu, "Why Airlines Want to Make You Suffer," *The New Yorker*, December 26, 2014, https://www.newyorker.com/business/currency/airlines-want-you-to-suffer.

11. Bonnie Toland, "Design for Conflict," Ignite Seattle lecture, June 10, 2019; available on YouTube at https://www.youtube.com/watch?v=l6hG2-jUaoI.

12. Mike Monteiro, *Ruined by Design: How Designers Destroyed the World, and What We Can Do to Fix It* (Mule Books, 2019).

13. Lisa W. Foderaro, "Navigation Apps Are Turning Quiet Neighborhoods into Traffic Nightmares," *New York Times*, December 24, 2017, https://www.nytimes.com/2017/12/24/nyregion/traffic-apps-gps-neighborhoods.html.

14. Rob Crilly, "Mark Zuckerberg Apologises for the Way Facebook Has Been Used to Divide People," *The Telegraph*, October 1, 2017, https://www.telegraph.co.uk/news/2017/10/01/mark-zuckerberg-apologises-way-facebook-has-used-divide-people.

15. Kyle Barron et al., "Research: When Airbnb Listings in a City Increase, So Do Rent Prices," *Harvard Business Review*, April 2019, https://hbr.org/2019/04/research-when-airbnb-listings-in-a-city-increase-so-do-rent-prices.

16. Scott Fulton III, "What Is Bias in AI Really, and Why Can't AI Neutralize It?" *ZDNet*, July 17, 2019, https://www.zdnet.com/article/what-is-bias-in-ai-really-and-why-cant-ai-neutralize-it.

17. Saoirse Kerrigan, "15 Examples of 'Anti-Homeless' Hostile Architecture That You Probably Never Noticed Before," *Interesting Engineering*, May 22, 2018, https://interestingengineering.com/15-examples-anti-homeless-hostile-architecture-that-you-probably-never-noticed-before.

18. Kunsido, "How the Dogon People in West Africa Promote Self-Constraint in Meetings," forum post by user "Wilbert," June 26, 2017, https://forum.kunsido.net/t/how-the-dogon-people-in-west-africa-promote-self-constraint-in-meetings/381.

CHAPTER 19: SOLUTIONS CREATE PROBLEMS

1. Emily S. Rueb, "To Reduce Hospital Noise, Researchers Create Alarms That Whistle and Sing," *New York Times*, July 9, 2019, https://www .nytimes.com/2019/07/09/science/alarm-fatigue-hospitals.html.

2. Austin Frakt, "Why Hospitals Should Let You Sleep," *New York Times*, December 3, 2018, https://www.nytimes.com/2018/12/03/upshot/why -hospitals-should-let-you-sleep.html.

3. Quoted in Christner Inc., "The Most Cruel Absence of Care," December 13, 2017, https://christnerinc.com/blog/the-most-cruel-absence-of-care.

4. Judith Kogan, "The Unsettling Sound of Tritones, the Devil's Interval," *All Things Considered*, NPR radio program; transcript posted October 31, 2017; available at https://www.npr.org/2017/10/31/560843189/the -unsettling-sound-of-tritones-the-devils-interval.

5. Rueb, "To Reduce Hospital Noise."

6. Quoted in Hadley Keller, "AD Remembers the Extraordinary Work of Eliel and Eero Saarinen," *Architectural Digest*, July 31, 2014, https://www.archi tecturaldigest.com/story/saarinen-father-and-son.

7. James Howard Kunstler, *The Geography of Nowhere: The Rise and Decline of America's Man-Made Landscape* (Free Press, 1994).

8. Stephen Moss, "End of the Car Age: How Cities Are Outgrowing the Automobile," *The Guardian*, April 28, 2015, https://www.theguardian .com/cities/2015/apr/28/end-of-the-car-age-how-cities-outgrew-the -automobile.

9. Jarrett Walker, "The Photo That Explains Almost Everything," *Human Transit*, September 21, 2012, https://humantransit.org/2012/09/the-photo -that-explains-almost-everything.html.

10. James Mayes, Twitter post, February 24, 2018, https://twitter.com/ james_mayes/status/967436803451117575.

11. To hear a broader vision for what a successful design future could look like, watch Paolo Malabuyo's August 22, 2015, lecture for the IDSA International Conference in Seattle, titled "Tech Ain't Enough," at https://www .idsa.org/videos/paolo-malabuyo.

PHOTO CREDITS

CHAPTER 1: EVERYTHING HAS A DESIGN

1. Notre Dame, © Loic Salan/Shutterstock.com.
2. Norman Door, used by permission of Cameron Moll.
3. Push/Pull plates, © ninuns/iStock.com.

CHAPTER 3: WHAT IS GOOD?

1. Hammer inventory, © Private Archive Hollein. From MAN transFORMS, *Concepts of an Exhibition*, edited by the Academy of Applied Arts, Löcker, 1989.
2. Bottle of onions, Scott Berkun.

CHAPTER 4: PEOPLE COME FIRST

1. Segways in use, © Spic/Shutterstock.com.

CHAPTER 5: EVERYONE DESIGNS SOMETHING

1. Backpack sketches, used by permission of Carly Hagins.

CHAPTER 6: THE STREET YOU LIVE ON

1. The Commissioners Map of The City of New York, 1807, by James S. Kemp, public domain.

2. Ibid.
3. Hundertwasserhaus, Vienna, © Mistervlad/Shutterstock.com.
4. Grand Canal Map, Venice, © Bardocz Peter/Shutterstock.com.

CHAPTER 7: STYLE IS A MESSAGE

1. Thai Tom restaurant, Seattle, Scott Berkun (taken from street).
2. Ba Bar Street Food, Seattle, Scott Berkun (taken from street).
3. Porsche 911 Carrera RS, by Lothar Spurzem, Creative Commons Attribution-ShareAlike 2.0, Germany (CC BY-SA 2.0 DE).
4. DIY car enhancement, Russia, © CEN. Used by permission.
5. Jolly Roger pirate icon, Oren neu dag, Creative Commons Attribution-ShareAlike 3.0 Unported (CC BY-SA 3.0).

CHAPTER 8: DESIGN IS HOW IT WORKS

1. Elevator user interface, Redmond, WA, Scott Berkun.

CHAPTER 9: SOMEONE HAS TO PAY

1. Woman putting on seatbelt, State Farm, Creative Commons 2.0.
2. Cadillac Hydra-Matic print ad, 1940 © General Motors, GM Media Archive/GM Heritage Center.

CHAPTER 10: THE POWERFUL DECIDE

1. Hand drawn map of Missoula, Montana, Tim Kordik.
2. Hand drawn map of Missoula, Montana, Tim Kordik.
3. Hand drawn map of Missoula, Montana, Tim Kordik.
4. Hand drawn map of Missoula, Montana, Tim Kordik.
5. Hand drawn map of Malfunction Junction, Missoula, Montana, Tim Kordik.
6. Map of Sykes–Picot 1916 division, Stanfords Geographical Establishment London, Map to Illustrate the Agreements of 1916 in Regard to Asia Minor, Mesopotamia, Public Domain.

CHAPTER 11: DESIGN IS A VERB

1. Create–learn loop graphic, Scott Berkun/Tim Kordik.
2. Framing example: Hammer from PublicDomainPictures.net, illustration by Fiona Lee.

CHAPTER 12: THE PASS IN YOUR POCKET

1. Delta boarding pass, Tyler N. Thompson, used by permission—http://passfail.squarespace.com/.
2. Grid example, Scott Berkun.
3. Grid example #2, Scott Berkun.
4. Redesigned pass, Tyler N. Thompson, used by permission—http://passfail.squarespace.com/.

CHAPTER 14: THE DESIGN REFLECTS THE TEAM

1. Graph showing population vs. ability, Inclusive Design Toolkit by Microsoft, used by permission.
2. Curb cut, Redmond Downtown Park, Redmond, WA, Scott Berkun.
3. Bodies and measurements, Donald Genaro, senior partner, Henry Dreyfuss Associates, Creative Commons 3.0.

CHAPTER 15: THE WAY WE THINK MATTERS

1. Scantron test form, Used with permission of Brian Cantoni, https://www.flickr.com/photos/cantoni/17314687602.
2. Undo Arrow Symbol free icon by Freepik, www.flaticon.com.

CHAPTER 16: VALUES AND TRADEOFFS

1. Seren toaster, Courtesy of BergHOFF International.
2. Nostalgia BSET300BLUE Retro Series 3-in-1, Courtesy of Nostalgia Products LLC.
3. Nostalgia BSET300BLUE Retro Series 3-in-1, Courtesy of Nostalgia Products LLC.
4. Lockheed Martin F-22 Raptor Cockpit, U.S. Air Force photo (080116-F-1234P-002), used by permission, National Museum of the US Air Force.
5. Xbox game controller, Evan Amos, used with permission from Microsoft.

CHAPTER 17: DESIGN IS HOW IT FLOWS

1. Parking row, Schiphol Airport, Used by permission of Mijksenaar, Amsterdam.
2. Interior wayfinding signage, Schiphol Airport, Amsterdam by Dale Simonson, https://www.flickr.com/photos/dale_simonson/5847303647, Creative Commons 2.0.

3. Urinal with fly target, by Gustav Broennimann, https://commons.wiki
 media.org/wiki/File:Urinal_Fly.JPG, Creative Commons Attribution 3.0.

CHAPTER 18: DESIGN FOR CONFLICT

1. Heretic's fork collar, used with permission of XR Brands, xrbrands.com.
2. Las Vegas slot machines by Yamaguchi 先生, https://commons.wikimedia
 .org/wiki/File:Las_Vegas_slot_machines.jpg, Creative Commons Attribution 3.0.
3. Middle seat on airplane, Photo by Gus Ruballo on Unsplash, https://
 unsplash.com/photos/sIsMNYQ26OQ, used by permission.
4. Bolts installed on the front steps of a building in France, to discourage
 sitting and sleeping by DC (DocteurCosmos), https://en.wikipedia.org/
 wiki/Hostile_architecture#/media/File:Boulons_anti-sdf_sur_un_perron_
 (Marseille,_France).jpg, Creative Commons Attribution- 3.0.

CHAPTER 19: SOLUTIONS CREATE PROBLEMS

1. Breezewood, PA, by Ben Schumin, https://en.wikipedia.org/wiki/Breeze
 wood,_Pennsylvania#/media/File:Breezewood,_Pennsylvania.jpg, used
 with permission, https://www.schuminweb.com/
2. King Street, Charleston, SC, by AudeVivere, https://commons.wikimedia
 .org/wiki/File:Charleston_king_street1.jpg, Creative Commons 2.5.
3. Comparison of space requirements on streets, © We Ride Australia. Used
 by permission.

ACKNOWLEDGMENTS

THANKS TO Ole Kirk Christiansen, the inventor of LEGO, who allowed me to discover that it's often more fun to design things than to use them (and my Mom, Judi, for buying it for me). I've spent my adult life designing things and studying design history, interests born from "playing" with what was "just a child's toy." Amazing.

Thanks to Neil Enns, Bob Baxley and Paolo Malabuyo, who read the first approach to this book, and shrugged. I'm glad they did as it led to this book, which took a different approach that I hope you liked.

The team at Page Two: Peter Cocking and Fiona Lee (designers), James Harbeck (editor), Melissa Edwards (copy editor), Alison Strobel (proofreader), Caela Moffet (project manager), Trena White, Annemarie Tempelman-Kluit (marketing director), Terri Rothman (photo permissions).

Illustrations by longtime collaborator Tim Kordik.

For early feedback: Anupam Choudhary, Kim Goodwin, Dana Chisnell, A.J. Hanneld, Christina Wodtke, Lisa deBettencourt, Sam Aquillano, Laura Klein, Bob Baxley, Nick Finck, Abby Covert, Dan Szuc and Jared Spool.

For feedback on drafts: Anupam Choudhary, Maurice Sy, Laura Klein, J.R. Richardson, Bonnie Toland, Shawn Murphy, August de los Reyes, Andrew Maier, Anders Mantere, Abby Covert and Di Dang. Thanks to Jill Stutzman for various opinions and suggestions. For interviews and ideas: David Cheng, Albert Tan, Simon Pan, Mike Davidson, Bryan Zug, Andrew Crow, Teresa Brazen, Braden Kowitz, Jessica Ivins, Alyssa Boehm, Delaney Cunningham, David Conrad, UXwine, Kayla McVey and Capri Burrell.

Thanks to the King County library system, and all librarians, especially those who help make the interlibrary loan service work so well.

Music listened to while writing this book: Sera Cahoone, Wintersleep, Frightened Rabbit, Charles Mingus, Social Distortion, Duke Ellington, Aimee Mann, Andrew Bird, Ben Harper, The Black Keys, DakhaBrakha, Gillian Welch, Cat Power, Chris Cornell, Elizabeth and the Catapult, Sonny Rollins, Ella Fitzgerald, The Felice Brothers, Lightnin' Hopkins, R.E.M., The Strokes, Mozart, Woody Guthrie, Jake Bugg, Chuck Berry, Mussorgsky and more.

INDEX

Note: Page numbers in *italics* indicate a photo or illustration.

ZDA-110-3-15-1, 5, 17

ABOUT THE AUTHOR

SCOTT BERKUN is the bestselling author of eight books on business and culture, including *Making Things Happen*, *The Myths of Innovation*, *Confessions of a Public Speaker* and *The Year without Pants: WordPress.com and the Future of Work*. He studied interaction design, computer science and philosophy at Carnegie Mellon University ('94) and spent most of his tech career leading project teams at WordPress.com and Microsoft. Over his career he designed dozens of product features, websites and user interfaces, used by millions of people.

Since 2003 he's been a full-time writer and speaker, and his work has appeared in the *New York Times*, *Washington Post*, *The Guardian*, *Wall Street Journal*, *Wired*, *Forbes*, *The Economist* and other media. He's a former contributor to *Harvard Business* and *Businessweek*, and has appeared often on CNBC, MSNBC, CNN and NPR for his expertise on various subjects. He gives many entertaining and inspiring lectures around the world at major events, corporations and universities, often as the keynote speaker; you can hire him to speak, or read his popular blog, at **scottberkun.com**, or find him on Twitter at **@berkun**.

Born and raised in Queens, NYC, he currently lives in the woods outside of Seattle.

COLOPHON

Cover design: Peter Cocking
Cover images: iStock
Interior design: Fiona Lee
Typefaces used: Lyon, Mark Pro, Remedy OT, Garamond

Book written with: quill pens, by oil lamp
Book actually written with: Mac Office 2013 (almost as frustrating)
Book actually written on: Mac Air 2013, 27″ Thunderbolt display

Peanut M&M's eaten during production: 8,322
Regular M&M's eaten: 16 unshared sharing-size packages
Bowls of phở or other noodle-based meals: incalculable
Bottles of 2 Towns Ciderhouse and Bulleit Rye: ditto

Calendar time since project began:
September 2014 to January 2020

Cross-country, ATL–SEA, train trips for research: 1

Completely abandoned outlines/drafts: 1 (sniff)
Number of drafts: 8
Words in this book: 34,592
Total words written (including those cut): 112,212
Cumulative time of George (cat) on
author's shoulders while writing: 10.5 hours
Number of facts made up in this list: not telling
Paradox: paradox

Special thanks to author's favorite escalope, Marlowe Shaeffer

This colophon ranked against author's other books' colophons: 4